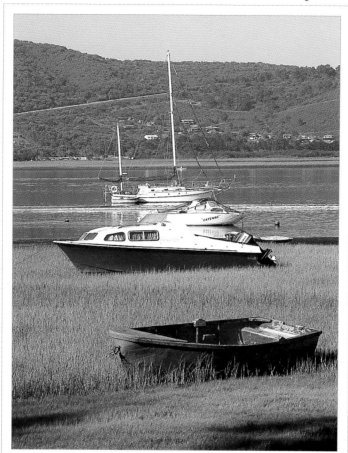

BEAUTIFUL
Garden Route

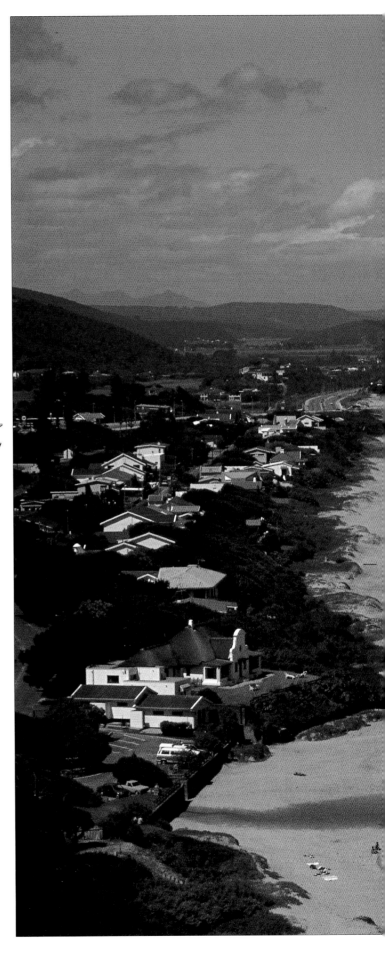

BEAUTIFUL
Garden Route

*W*ilderness Beach provides a heart-stopping view from Dolphin's Point – a compelling vantage point on the sea cliffs high above the Kaaimans River mouth. From Dolphin's Point, the highway drops steeply to sea level, sweeping on between the densely vegetated dunes, across the Touw River mouth and eastwards through the Wilderness National Park and Knysna National Lake Area.

*D*er Blick auf den Strand und das Dorf von Wilderness vom Aussichtspunkt Dolphin's Point aus ist einfach atemberaubend – an dieser Stelle, die auf den Felsen hoch über der Mündung des Kaaimans River liegt, sollte der Besucher angehalten haben. Von Dolphin's Point an fällt die Straße steil zum Meer ab und windet sich durch die dichtbewachsenen Dünen, über die Mündung des Touw River, führt dann weiter östlich durch den Wilderness-Nationalpark und die Seenplatte des Knysna-National-Lake-Area.

*L*e spectacle extraordinaire de Wilderness Beach vu de Dolphin's Point (la pointe du dauphin) – un incomparable point de vue perché au sommet des falaises surplombant l'embouchure de la rivière Kaaimans. De Dolphin's Point, la route descend en pente raide jusqu'au niveau de la mer, s'élançant entre les dunes à la végétation dense et traversant l'embouchure de la rivière Touw. Elle se dirige alors vers l'est, passant par le Parc National de Wilderness et le Knysna National Lake Area (la région nationale des lacs de Knysna).

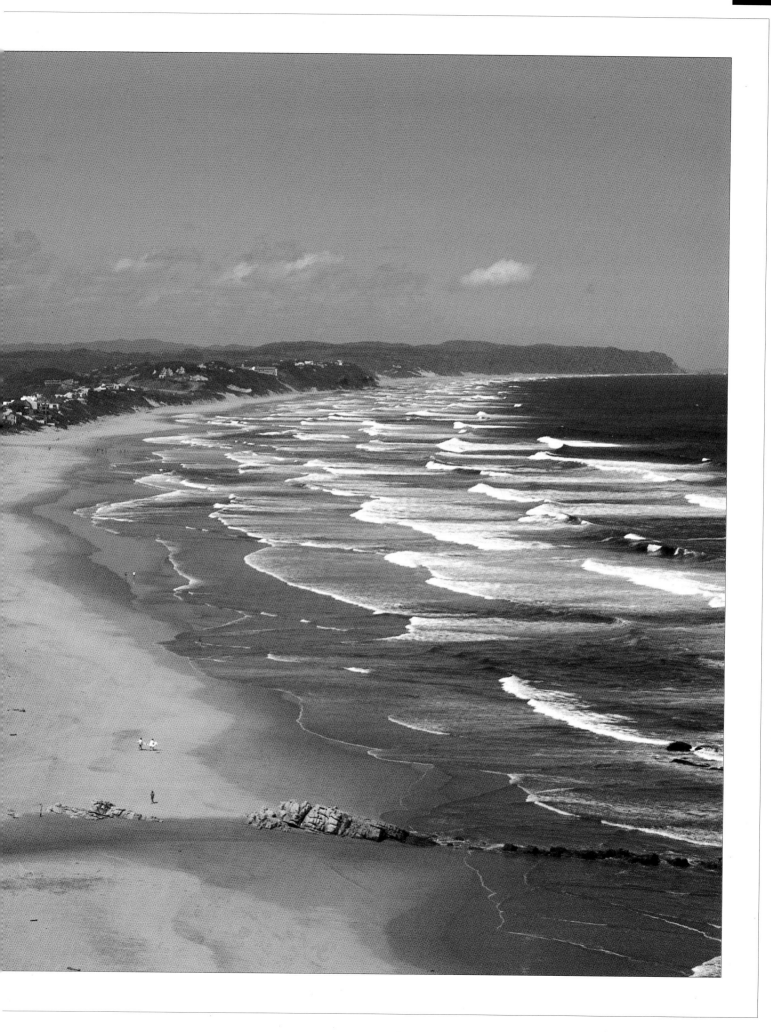

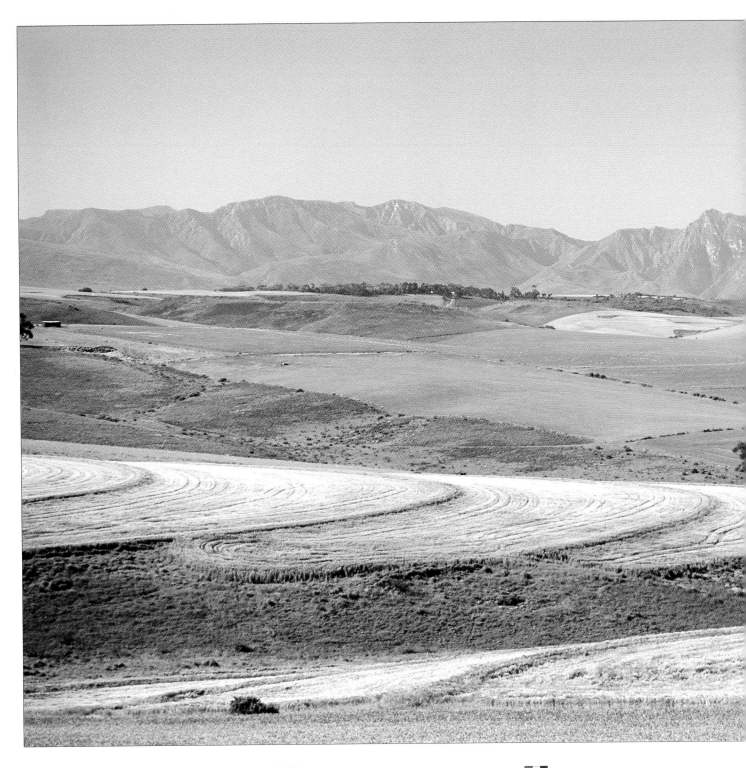

Above: *Green and golden, the Overberg, western gateway to the Garden Route, where wheat, cattle and vines are farmed between the Langeberg range and the sea.* Opposite top: *Swellendam, South Africa's third oldest settlement, is steeped in 250 years of history.* Opposite centre: *The Breede River, lifeblood of a vast, intensively cultivated valley, gathers momentum for 310 kilometres, before reaching the sea at Witsand. Recreation includes rafting through the winelands.* Opposite bottom: *Bungee jumpers leap from the Gourits River bridge between Albertinia and Mossel Bay.*

Oben: *Grün und Gold – das sind die Farben des Overberg, dem westlichen Tor zur Garden-Route, wo man Weizen und Wein anbaut und Vieh hält. Der Berg liegt zwischen Langeberg und Meer.* Rechts oben: *Swellendam, die drittälteste Niederlassung in Südafrika, kann auf 250 Jahre Geschichte zurückblicken.* Rechts Mitte: *Der Fluß Breede, Lebensader eines weitläufigen Tals, fließt auf seinem 310 Kilometer langen Weg immer schneller, bis er bei Witsands ins Meer mündet.* Rechts unten: *'Bungee Jumpers' sprigen von der Brücke des Gourits, einem Fluß zwischen Albertinia und Mossel Bay.*

Ci-dessus: *L'Overberg, le seuil de la Route des Jardins, est situé entre la chaîne du Langeberg et la mer. On y exploite le froment, la vigne et le bétail.* Ci-contre, en haut: *La troisième ville la plus ancienne de l'Afrique du Sud: Swellendam, imprégnée de 250 ans d'histoire.* Ci-contre, au centre: *La rivière Breede, artère vitale d'une vallée aux cultures intensives, elle s'élance sur 310 kilomètres avant de se jeter dans la mer à Witsand. Une des activités populaires: descendre la rivière en radeau entre les vignobles.* Ci-contre, en bas: *Des sauteurs de benji se précipitent du pont de la rivièr Gourits, entre Albertinia et Mossel Bay.*

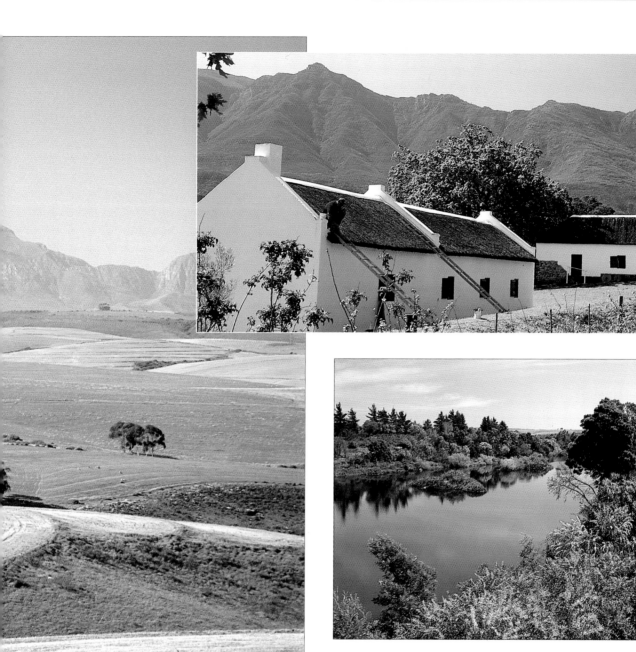

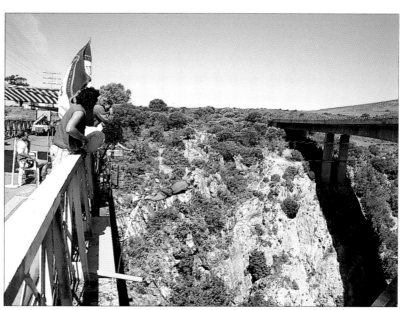

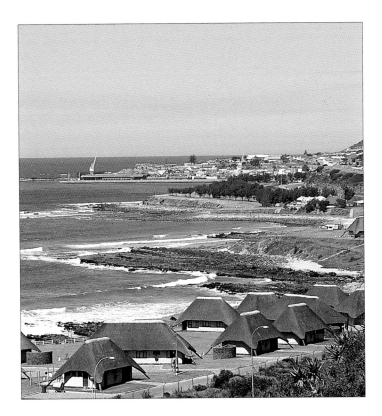

Above: *The town of Mossel Bay is dominated by holiday resorts and leisure activities.* Right: *Mossel Bay's hospitable port has provided shelter since the Portuguese explorer Bartolomeu Dias bypassed the Cape and landed there in 1488. The yacht basin lies in the eastern curve of the bay, once a major export point for ostrich feathers during the boom days of the last century.* Bottom left: *Dias' caravel is beautifully replicated in the excellent museum complex.* Opposite bottom centre: *Mossel Bay is blessed with one of the kindest climates in the world.* Opposite bottom right: *The 'Post Office Tree', where early seafarers left messages for passing ships.*

Oben: *Das Bild der Stadt Mossel Bay wird von Ferienunterkünften und Freizeitangeboten geprägt.* Rechts: *Seit der portugiesische Entdecker Batholomeus Diaz 1488 das Kap umsegelte und dort landete, bot der einladende Hafen von Mossel Bay Seeleuten Schutz. In der östlichen Biegung der Bucht liegt der Jachthafen, einstmals bedeutende Schaltstelle für den Export von Straußenfedern während des Booms im letzten Jahrhundert.* Unten links: *Die Caravelle von Diaz wurde originalgetreu nachgebaut und ist im schönen Museumskomplex des Ortes zu besichtigen.* Unten Mitte: *Mossel Bay hat ein besonders angenehmes Klima.* Unten rechts: *Der 'Post Office Tree' (Postbaum) war eine Art Anschlagbrett, wo die die frühen Seefahrer Botschaften für nachfolgende Schiffe und deren Besatzungen hinterließen.*

Ci-dessus: *La ville de Mossel Bay est un centre estival et offre de nombreuses activités de loisir.* En haut à droite: *Le port de Mossel Bay offre un abri sûr; le refuge de la baie est connu depuis que l'explorateur portugais Bartolomée Dias y débarqua en 1488 après avoir contourné le Cap. Le bassin pour yachts est situé à l'est de la baie; c'est d'ici que, lors du boom du siècle dernier, étaient exportées les plumes d'autruches.* En bas, de gauche à droite: *Une très belle reproduction de la caravelle de Dias est exposée au musée. Mossel Bay jouit d'un des plus plaisants climats du monde. Le 'Post Office Tree' (l'arbre-bureau de poste) où les navigateurs d'antan laissaient leurs lettres pour être ramassées par les bateaux de passage.*

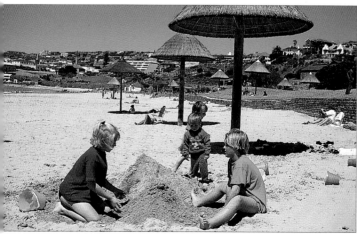

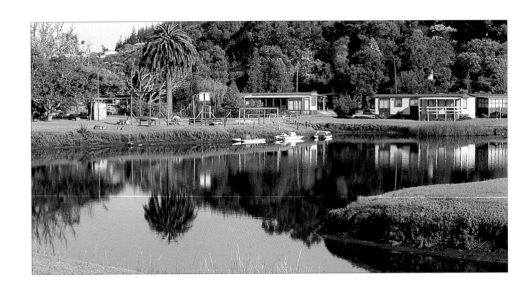

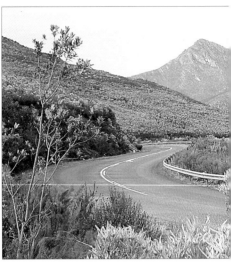

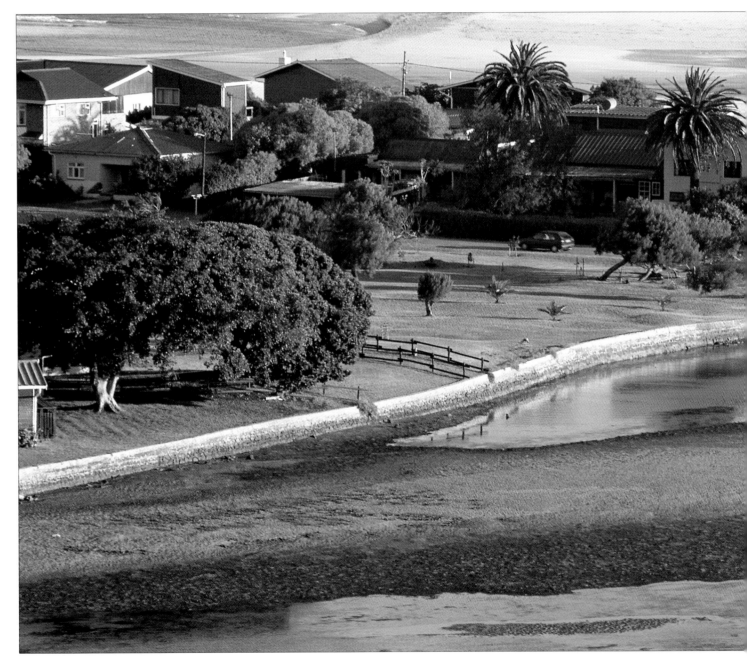

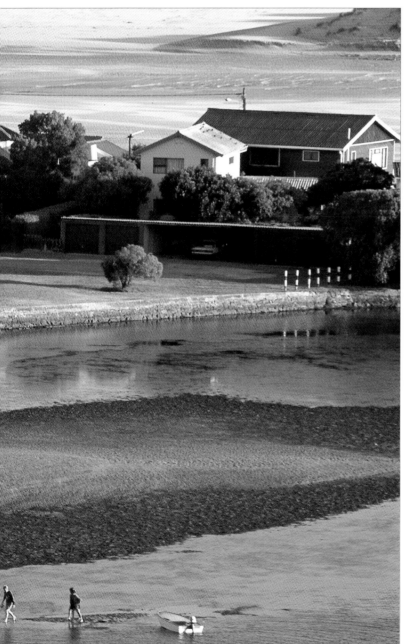

⌗ Left and opposite top left: *Idyllic holiday resorts have developed around the river mouths, such as Great Brak and its sibling, Little Brak, where small islands and wooded banks are reflected in the peaceful, peat-coloured water.* Top centre: *At Mossel Bay, the Garden Route highway probes into the interior via the old Robinson Pass where* fynbos *grows high in the Outeniqua Mountains.* Above: *Halfway house between Mossel Bay and Oudtshoorn – Eight Bells Holiday Farm, at the foot of the Robinson Pass.*

▬ Links und ganz links oben: *An den Flußmündungen, wie beispielsweise Great Brak und Little Brak, sind idyllische Feriensiedlungen entstanden und kleine Inseln und bewaldete Uferbänke spiegeln sich dort im bräunlichen Wasser.* Links oben Mitte: *Bei Mossel Bay biegt die Fernstraße der Garden-Route ins Inland ab und führt weiter über den alten Robinson Paß, auf dem, hoch oben in den Outeniquabergen,* Fynbos *wächst.* Oben: *Auf halbem Weg zwischen Mossel Bay und Oudtshoorn liegt die Farm 'Eight Bells' zu Füßen des Robinson Passes.*

▮▮ A gauche, et ci-contre en haut à gauche: *De splendides stations estivales ont été établies autour de l'embouchure des rivières, comme à Great Brak et à son petit cousin, Little Brak, où les îlots et les rivages boisés se reflètent dans l'eau paisible.* En haut, au centre: *A Mossel Bay, la Route des Jardins se détourne vers l'intérieur par la Robinson Pass (le col Robinson) et les montagnes de l'Outeniqua, où foisonne le* fynbos, *la végétation indigène.* Ci-dessus: *A mi-chemin entre Mossel Bay et Oudtshoorn – le gîte de vacances Eight Bells Holiday Farm, au pied de la Robinson Pass.*

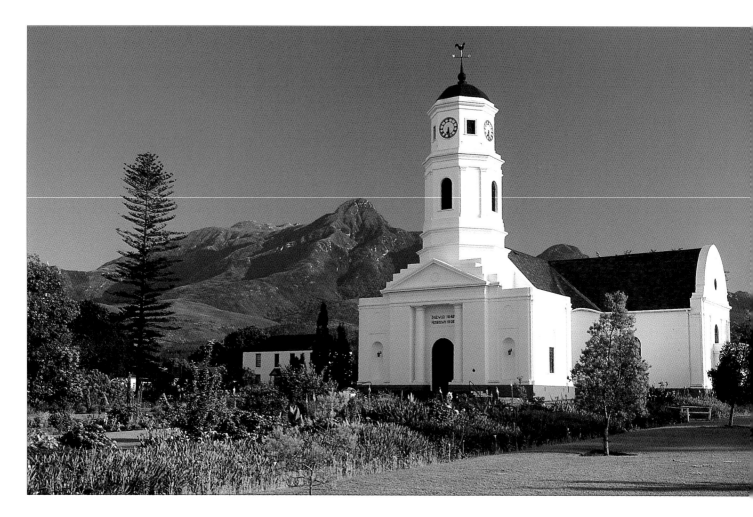

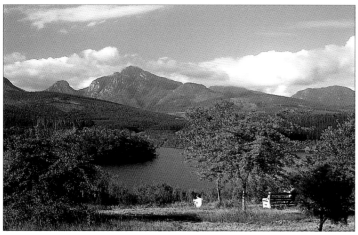

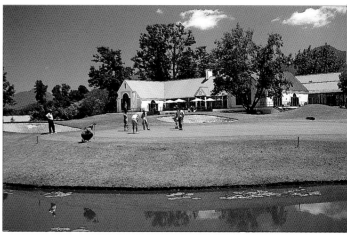

Top: *George, capital of the Garden Route, is an ideal starting point for excursions to the interior or to the nearby coastal resorts of Herolds Bay, Victoria Bay and the Wilderness. George, founded in 1811 and named after King George III, has broad, tree-lined streets and stately buildings, such as the Dutch Reformed Church.* Above: *The moisture-laden climate encourages lush vegetation in the George district.* Above right: *Fancourt Hotel and Country Club Estate at Blanco – one of South Africa's premier championship golf courses, where the Fancourt Hall of Fame took place in 1991 and the Bell's Cup in the mid-1990s.*

Ganz oben: *George, die Kreisstadt der Garden-Route, ist ein guter Ausgangspunkt für Ausflüge ins Inland oder zu den Küstenorten wie Herolds Bay, Victoria Bay und Wilderness. George wurde 1811 gegründet und nach dem englischen König Georg III benannt. Der Ort hat baumbestandene Straßen und eindrucksvolle Gebäude wie beispielsweise die Niederländisch-Reformierte Kirche.* Oben links: *Durch das feuchte Klima weist die Umgebung von George eine üppig grüne Vegetation auf.* Oben rechts: *Der Golfplatz des Fancourt Hotel and Country Club ist weltberühmt; dort werden viele Turniere ausgetragen.*

En haut: *George, la capitale de la Route des Jardins, est une base idéale pour les excursions vers l'intérieur ou aux stations balnéaires de Herolds Bay, Victoria Bay et Wilderness. Fondée en 1811, et appelée d'après le roi George III, la ville possède de larges rues bordées d'arbres et d'imposants édifices tels que la Dutch Reformed Church (l'Eglise Hollandaise Réformée).* Ci-dessus, à gauche: *La végétation luxuriante des environs de George est due au climat saturé d'humidité.* Ci-dessus: *L'hôtel Fancourt et Country Club Estate de Blanco, un des prestigieux terrains de golf d'Afrique du Sud.*

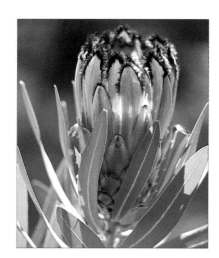

Far left: *The tiny St Marks Anglican Cathedral, which endows George with city status, is the smallest in the southern hemisphere. Sandstone cut from the Outeniqua mountains casts a warm light in the cathedral* (centre). Left: *About 3 000 of South Africa's flowering plant species are found in the habitats of the southern coastline, hence the title 'Garden Route'. The* Protea neriifolia, *with its exuberant colour and black-brushed petals, is one of the most flamboyant floral inhabitants of the region.* Below: *Ten kilometres outside George, Herolds Bay has been a holiday resort for over 100 years.*

Ganz links: *Die winzige, anglikanische Kathedrale von St. Marks, der George seinen Stadtstatus verdankt, ist das kleinste Gotteshaus auf der südlichen Halbkugel. Der Sandstein, der aus den Outeniquabergen geschlagen wurde, evoziert im Inneren ein warmes Licht* (links unten). Links: *Etwa 3 000 Exemplare der Blütenpflanzen Südafrikas findet man im Umfeld des südlichen Küstenstreifens, daher rührt auch der Name 'Garden Route'. Die* Protea neriifolia, *mit ihren farbenfreudigen, schwarzgeränderten Blüten, ist eine der prächtigsten Blumen des Gebietes.* Unten: *Seit mehr als 100 Jahren ist Herolds Bay, 10 Kilometer vor George gelegen, ein beliebter Ferienort.*

En haut, à gauche: *La minuscule cathédrale anglicane de St Marc est la plus petite de l'hémisphère austral. Le grès de l'Outeniqua dont elle est construite, exalte la lumière chaude et agréable projetée entre ses murs* (à gauche). En haut, à droite: *Approximativement 3 000 des espèces de fleurs d'Afrique du Sud ont leur habitat sur la côte sud, d'où son nom de 'Garden Route' ou la Route des Jardins. Le* Protea neriifolia, *avec ses éclatantes couleurs et ses pétales de velours noir, est une des plantes les plus resplendissantes de la région.* Ci-dessous: *Herolds Bay (près de George) a été une station balnéaire pour plus de 100 ans.*

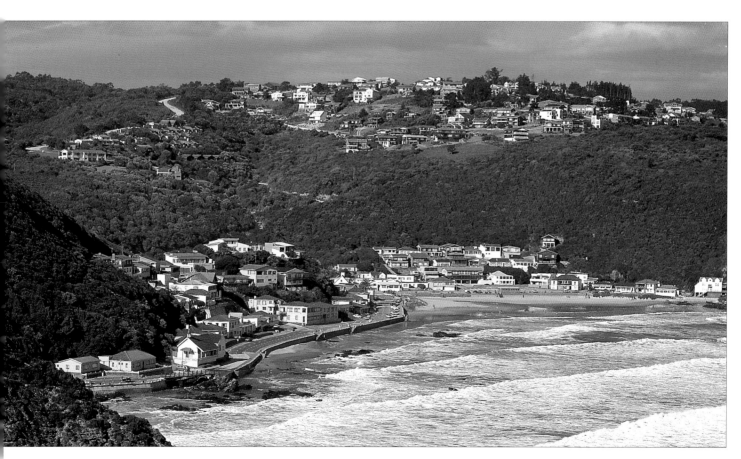

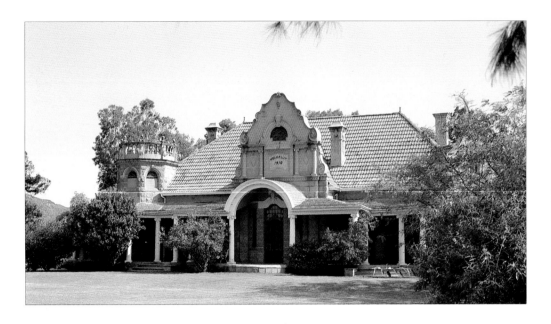

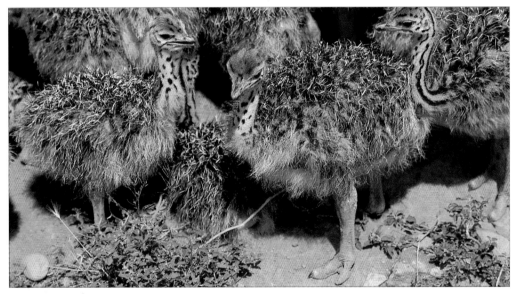

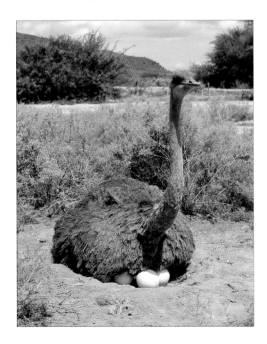

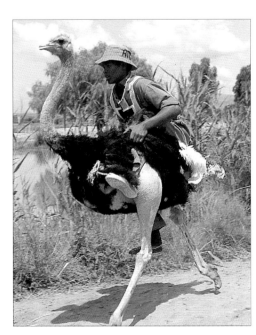

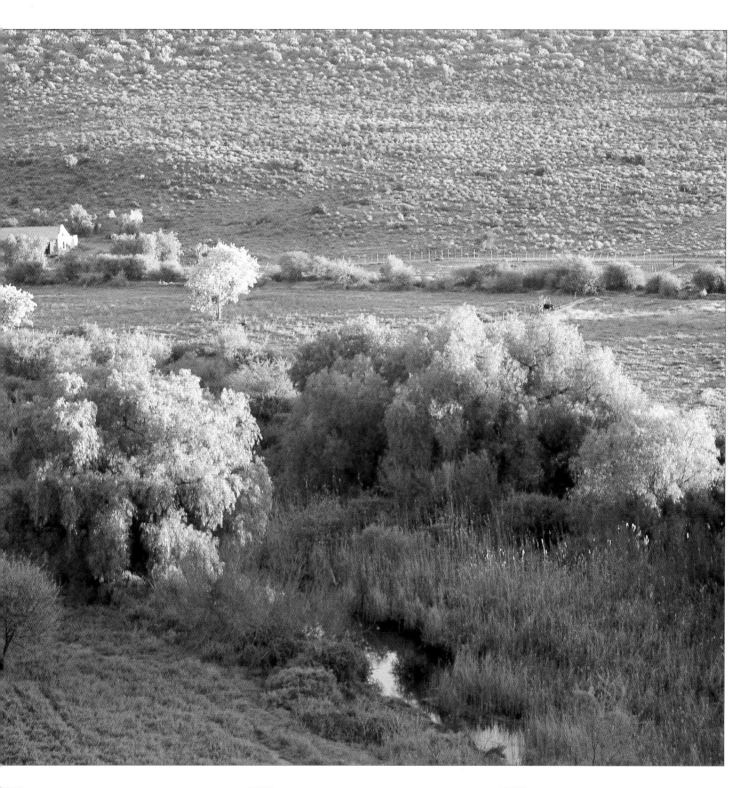

Opposite top: *Oudtshoorn, the ostrich capital of the world, owes its being to the flightless bird* (Struthio camelus) *that brought undreamt-of prosperity to the town beyond the Outeniquas. Feather barons built sandstone 'palaces', such as Welgeluk.* Opposite centre: *Chicks in their first year are vulnerable to disease.* Bottom left: *By day, females sit camouflaged on the nest.* Bottom right: *Ostriches are the fastest animals on two legs, reaching speeds of 50-70 kilometres an hour.* Above: *Beyond the coastal mountains is a sudden transition to semi-arid Little Karoo vegetation.*

Links oben: *Oudtshoorn, das Straußen-zentrum der Welt, verdankt sein Bestehen dem fluglosen Vogel* (Struthio camelus), *der dem Ort ungeahnten Reichtum brachte. Die 'Federbarone' bauten sich Paläste aus Sandstein – ein Beispiel ist Welgeluk.* Links Mitte: *Die Jungen sind im ersten Lebensjahr sehr anfällig für Krankheiten.* Ganz links: *Am Tag sitzen die Weibchen auf dem Nest.* Links: *Der Strauß ist das schnellste Tier auf zwei Beinen und bringt es auf 50 bis 70 km/h.* Oben: *Hinter dem Küstengebirge beginnt die Halbwüstenvegetation der Kleinen Karru.*

Ci-contre, en haut: *Oudtshoorn, la capi-tale du monde de l'autruche, doit sa bonne fortune à l'oiseau coureur* (Struthio camelus). *Les 'barons de la plume d'autruche' érigèrent des 'palais' en grès, comme celui de Welgeluk.* Ci-contre, au centre: *Durant leur première année les autruchons sont sensibles à la maladie.* En bas, à gauche: *Les femelles, camouflées, couvent sur le nid.* En bas, à droite: *Les autruches sont les bipèdes les plus rapides du monde animal: elles peuvent faire entre 50 et 70 kilomètres à l'heure.* Ci-dessus: *Dans le Petit Karoo, la végétation devient semi-aride.*

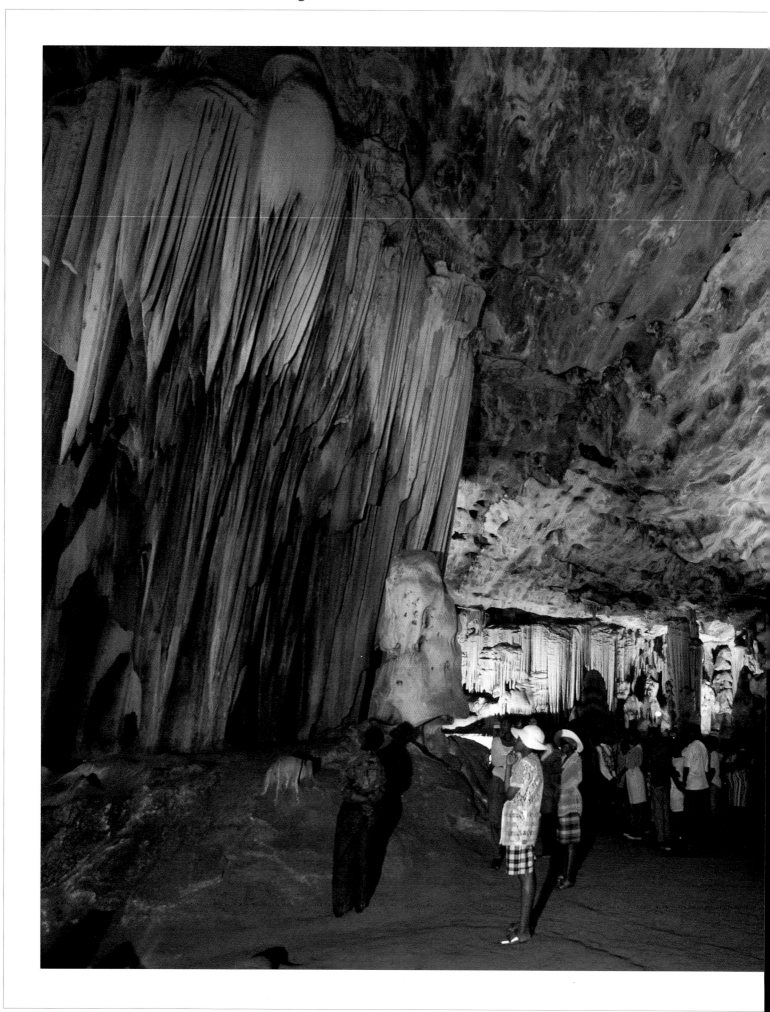

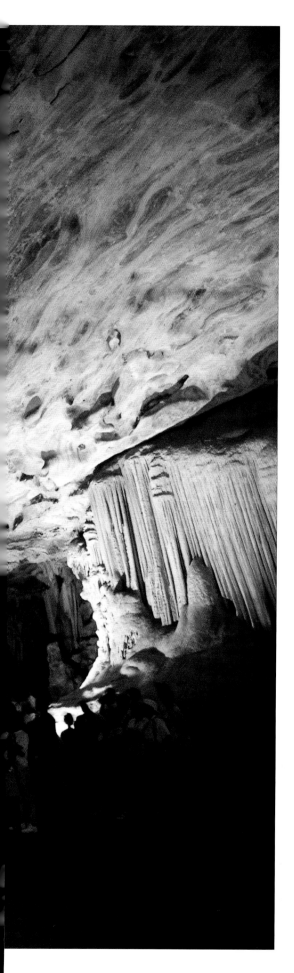

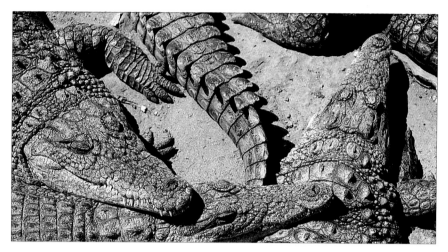

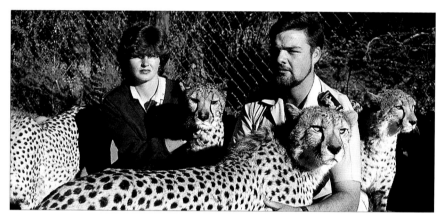

🇬🇧 Left: *Considered among the finest natural dripstone caves in the world, the Cango Caves gouge deep into the heart of the Swartberg range, dividing the Little and Great Karoo. An awesome labyrinth of chambers and tunnels with intricate calcified limestone formations, the Cango Caves have been known to man since at least the Middle Stone Age.* Top: *Crocodile viewing at close quarters thrills visitors to the Cango Crocodile Ranch and Cheetahland, where at least 200 reptiles, from 30 centimetres to four metres in length, are on display.* Above: *Walks on raised walkways are conducted from Cheetahland, centre of the world's fifth largest cheetah-breeding programme. The park has also embarked on a programme to breed endangered African wild dogs, of which there are fewer than 2 000 survivors world-wide.*

🇩🇪 Links: *Die Cango-Höhlen, die sich tief in das Herz der Swartberge hineinziehen, zählen zu den schönsten, natürlichen Tropfsteinhöhlen der Welt. Die Kleine und Große Karru werden durch die Höhlen getrennt. Sie sind ein ehrfurchtgebietendes Labyrinth an Kammern und Tunneln mit komplizierten Formationen aus erstarrtem Kalkstein, und seit der Mittleren Steinzeit dem Menschen bekannt.* Ganz oben: *Auf der Cango-Crocodile-Ranch-and-Cheetahland können Touristen Krokodile aus nächster Nähe bewundern, ebenso wie an die 200 Reptilien, zwischen 30 Zentimetern und 4 Metern lang, besichtigen.* Oben: *Von Cheetahland aus kann man Wanderung durch Gepardengebiet unternehmen; es ist auch Zentrum einer der fünf großen Gepardenaufzuchtprojekte. Der Park hat ebenfalls ein Programm zur Aufzucht der stark bedrohten Hyänenhunde, von denen es weltweit gerade noch 2 000 Exemplare gibt.*

🇫🇷 A gauche: *Considérées comme étant les plus belles grottes de calcaire du monde, les grottes de Cango pénètrent profondément dans les entrailles des montagnes du Swartberg qui divisent le Petit et le Grand Karoo. Un énorme labyrinthe de chambres et de galeries aux complexes formations de calcaire, les grottes de Cango sont connues à l'homme depuis au moins le milieu de l'âge de la pierre.* En haut: *Observer les crocodiles de près est une des sensations fortes que les visiteurs peuvent éprouver au 'Cango Crocodile Ranch and Cheetahland', où sont exhibés plus de 200 de ces reptiles mesurant entre 30 centimètres et quatre mètres.* Ci-dessus: *Cheetahland est le cinquième centre de reproduction de guépards du monde; il est possible d'y faire des randonnées à pied. La réserve a aussi entrepris un projet de reproduction pour le chien sauvage d'Afrique, une espèce menacée, dont il reste moins de 2 000 survivants dans le monde.*

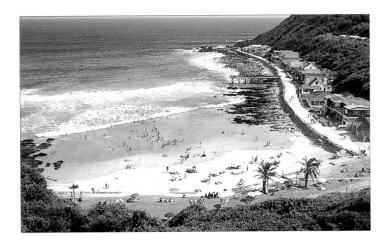

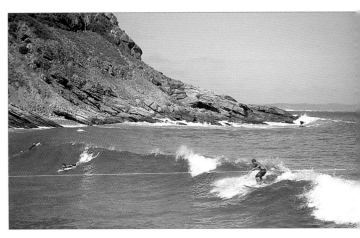

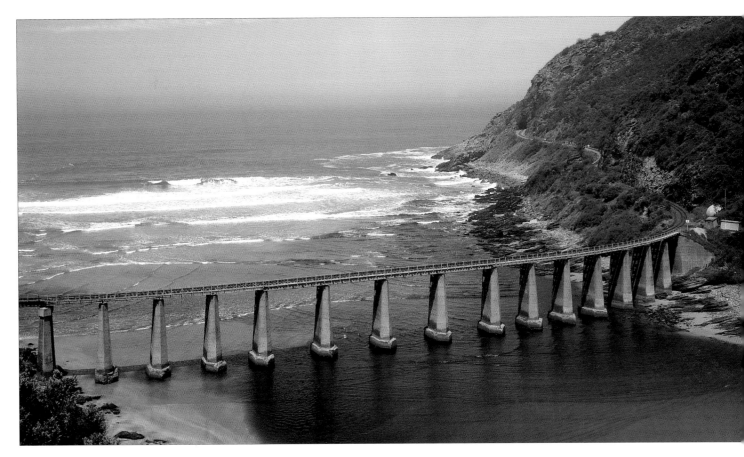

Top left and right: *Victoria Bay, tucked into a snug curve on the coast near George, is ideal 'surf turf'.* Above: *The Kaaimans River emerges from a gorge to spill into the ocean just west of Wilderness. A narrow gauge railway bridge spans the divide, allowing passage for the Outeniqua Choo-Tjoe, shuttling a daily load of passengers and goods between George and Knysna.* Opposite top left: *Isolated by a ribbon of water, a holiday home hugs the forested cliffside on the far bank of the Kaaimans River.* Opposite top right: *Getting away from it all under the canopy of indigenous forest, which blankets one third of the Garden Route.* Opposite bottom: *Wilderness Lagoon at the Touw River mouth (in the distance) is the start of an extensive wetland system incorporating five lakes running eastwards almost to Knysna.*

Ganz oben links und rechts: *Victoria Bay schmiegt sich bei George an die Küste und ist ein ideales Surfgebiet.* Oben: *Der Kaaimans River tritt aus einer Schlucht hervor und ergießt sich westlich von Wilderness in den Ozean. Eine Eisenbahnbrücke überspannt die Schlucht und ermöglicht dem Outeniqua Tschu-Tschu seine tägliche Fahrt zwischen George und Knysna.* Rechts oben: *In idyllischer Ruhe liegt ein Ferienhaus am Ufer des Kaimaans.* Ganz rechts oben: *Wer die Ruhe sucht, kann sich in die Abgeschiedenheit des Waldes zurückziehen, der ein Drittel der Garden-Route bedeckt.* Rechts: *Die Wilderness Lagune an der Mündung des Touw River ist der Anfang einer ausgedehnten Seenplatte, die fünf Seen einschließt und in östlicher Richtung faßt bis nach Knysna reicht.*

En haut, à gauche et à droite: *Victoria Bay, près de George, est le domaine des surfeurs.* Ci-dessus: *La rivière Kaaimans émerge d'une gorge pour se jeter dans l'océan Indien, à l'ouest de Wilderness. Un pont de chemin de fer la traverse. La ligne est empruntée quotidiennement par l'Outeniqua Choo-Tjoe, un train à vapeur.* Ci-contre, en haut à gauche: *Une maison de vacances est accolée au pied de la falaise boisée, sur la rive opposée de la rivière Kaaimans.* Ci-contre, en haut à droite: *La forêt indigène couvre un tiers de la Route des Jardins .* Ci-contre, en bas: *La lagune de Wilderness, à l'embouchure de la rivière Touw (dans le fond), est le point de départ d'un système marécageux comprenant cinq lacs, s'étirant vers l'est, touchant presque Knysna.*

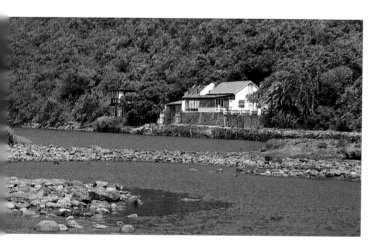

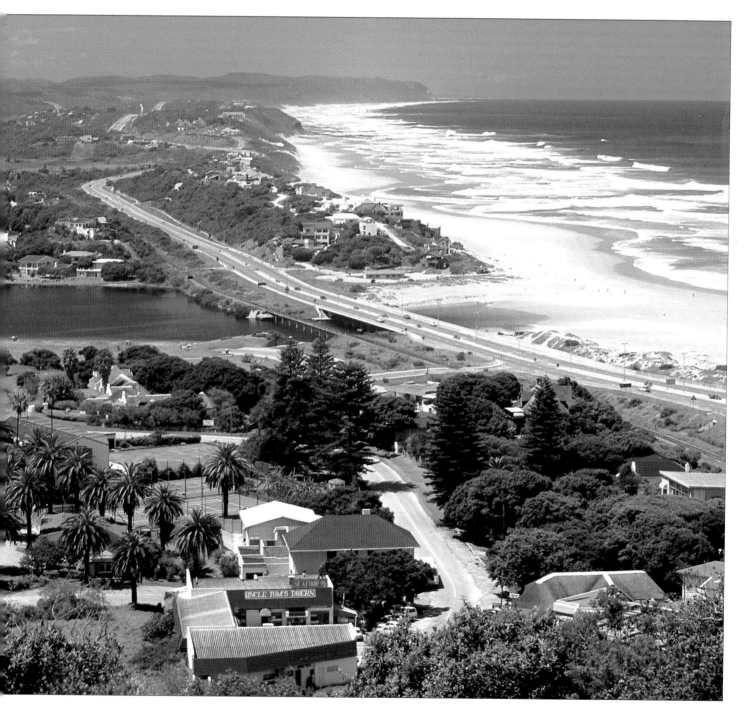

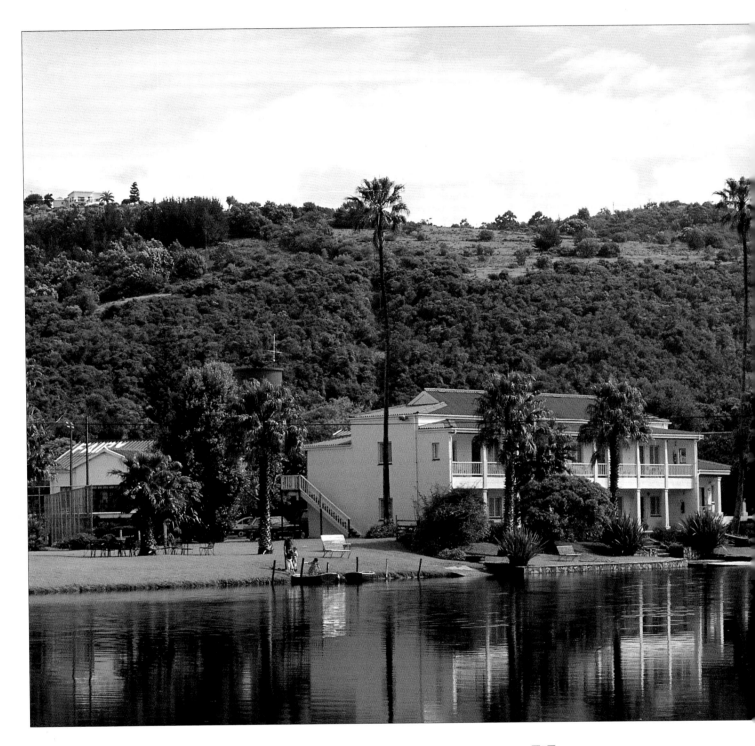

Above: *Resorts, camp sites and trails cater for man's leisure needs in the Wilderness National Park. Fairy Knowe Hotel has riverside rooms and thatched rondavels on the banks of the Touw River.* Opposite top: *Island Lake, which is part of the Wilderness Lake District.* Opposite centre: *The Lakes Holiday Resort lies on the reed-fringed bank of a hairpin bend in the Touw River.* Bottom left: *The National Parks Board chalets provide comfortable, inconspicuous accommodation at the juncture of the Touw and Serpentine.* Bottom right: *Four kingfisher species, including the malachite kingfisher (Alcedo cristata), are among the 160 bird species in the Wilderness National Park.*

Oben: *Rastlager und Wanderwege erfüllen die Freizeitbedürfnisse des Menschen im Wilderness-Nationalpark. Das Hotel Fairy Knowe bietet Zimmer, die auf den Fluß blicken, sowie strohgedeckte Rundhütten am Ufer des Touw.* Rechts oben: *Island Lake in Wilderness.* Rechts Mitte: *Das Lakes Holiday Resort liegt an den schilfbestandenen Ufern des Touw, der an dieser Stelle eine scharfe Biegung formt.* Rechts: *Die Rasthütten des National Parks Board am Zusammenfluß des Touw und Serpentine sind komfortable Unterkünfte.* Ganz rechts unten: *Vier Eisvogelarten, darunter der Malachiteisvogel (Alcedo cristata), gehören zu den 160 Vogelarten im Wilderness Nationalpark.*

Ci-dessus: *Le Parc National de Wilderness offre le nécessaire pour les loisirs: centres de vacances, terrains de camping et randonnées pédestres. L'hôtel Fairy Knowe a des chambres donnant sur la rivière, et des huttes au toit de chaume sur la rive même de la rivière Touw.* Ci-contre, en haut: *Island Lake à Wilderness.* Ci-contre, au centre: *Le Lakes Holiday Resort est situé dans une courbe de la rivière Touw.* En bas, à gauche: *Les chalets du National Parks Board offrent un gîte confortable au confluent de la rivière Touw et du Serpentine.* En bas, à droite: *Ce martin-pêcheur malachite (Alcedo cristata) est un des oiseaux parmi les 160 espèce au Parc National de Wilderness.*

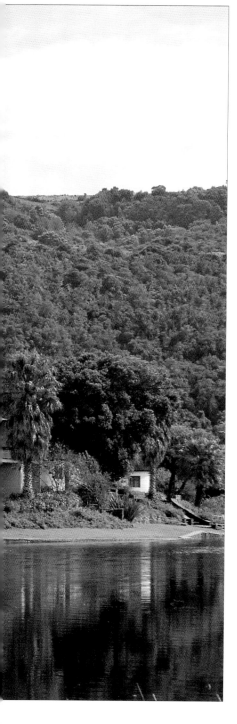

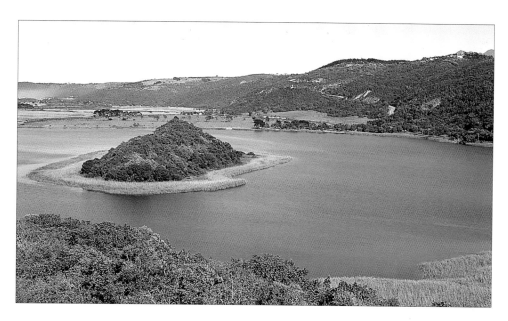

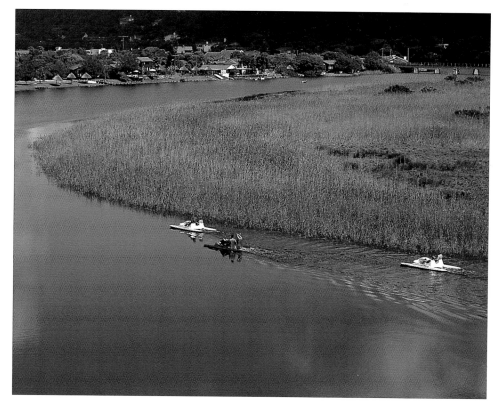

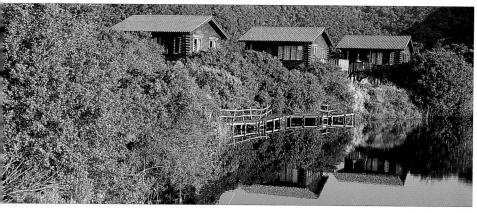

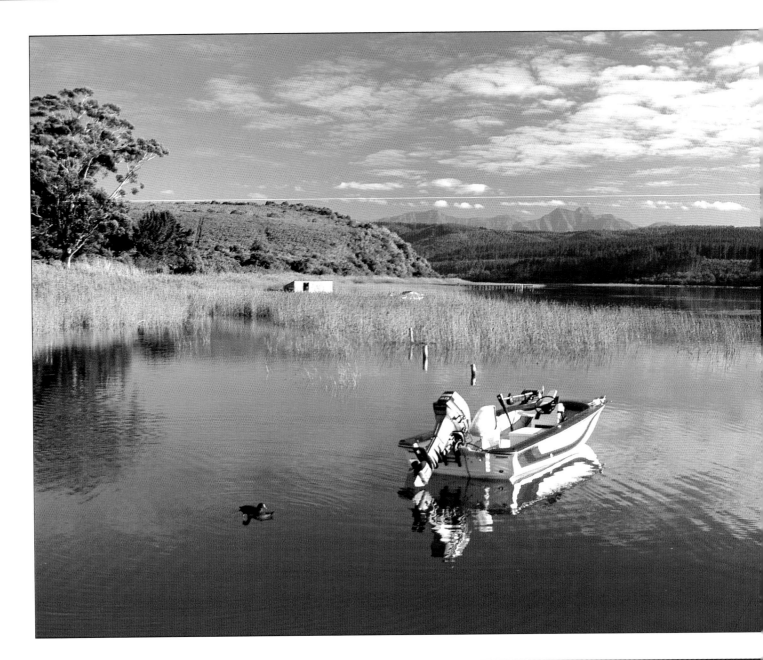

Opposite top: *Swartvlei is fed by rivers rising in the Outeniquas.* Opposite bottom left: *The only freshwater lake in the system, Groenvlei is stocked with black bass.* Opposite bottom right: *The blackwinged stilt (Himantopus himantopus), one of the waterbirds living in the Wilderness wetlands.* Right: *Pedal boats, row boats and canoes at Trail's End Camp, Swartvlei. The National Parks Board encourages recreational activities throughout the Wilderness National Park, but water-skiing is limited to Island Lake and Swartvlei.* Below: *Swartvlei finds its way to the sea between Sedgefield's vegetated dunes.*

Links: *Der Swartvlei wird von Flüssen gespeist, die in den Outeniquabergen entspringen.* Ganz links unten: *Der einzige Süßwassersee in der Seenplatte ist der Groenvlei; dort gibt es Schwarzbarsche.* Links unten: *Der Stelzenläufer (Himantopus himantopus) ist einer der Wasservögel, die in den unterschiedlichen Ökosystemen der Wilderness Feuchtgebiete beheimatet sind.* Rechts: *Bootleben am Trail's End Camp am Swartvlei. Der NPB fördert Freizeitgestaltung im Wilderness-Nationalpark, doch Wasserski kann man nur auf den Seen Island und Swartvlei laufen.* Unten: *Durch die Dünen bei Sedgefield fließt der Swartvlei zum Meer.*

Ci-contre, en haut: *Le Swartvlei est alimenté par des rivières ayant leurs sources dans les Outeniquas.* Ci-contre, en bas à gauche: *Le seul lac d'eau douce, le Groenvlei, abonde en perches.* Ci-contre, en bas à droite: *Un échassier aux ailes noires (Himantopus himantopus), une des nombreuses espèces d'oiseaux aquatiques vivant dans les marais de Wilderness.* A droite: *Pédalos, canots et canoës au Trail's End Camp, au Swartvlei. Le National Parks Board favorise les activités de loisir dans le Parc National de Wilderness, mais le ski nautique n'est permis qu'à Island lake et Swartvlei.* Ci-dessous: *Le Swartvlei se faufile entre les dunes de Sedgefield.*

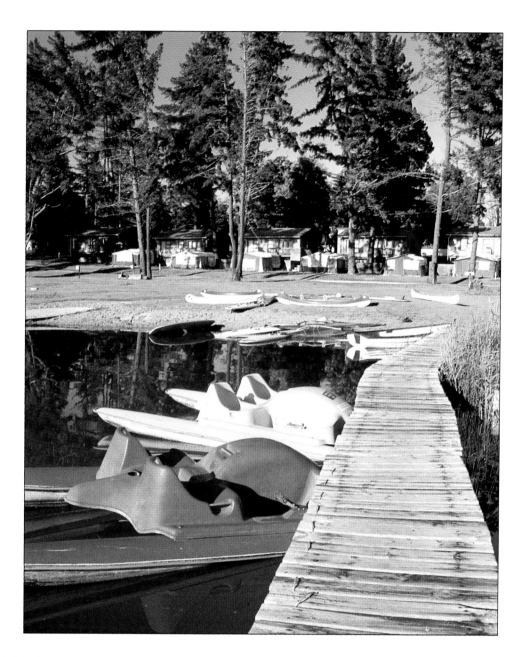

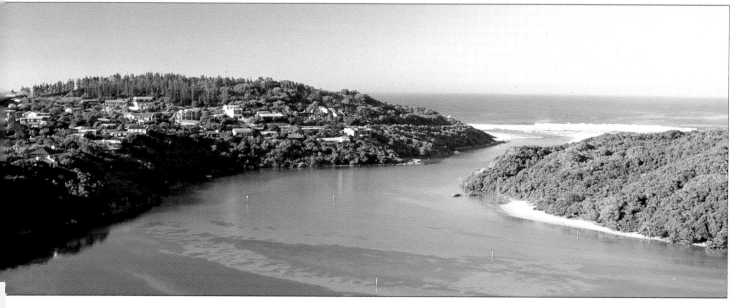

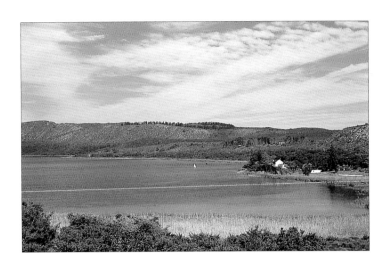

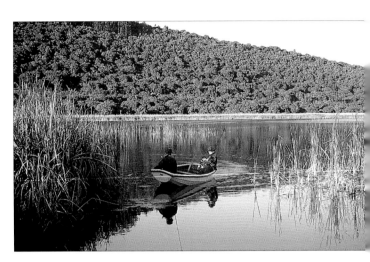

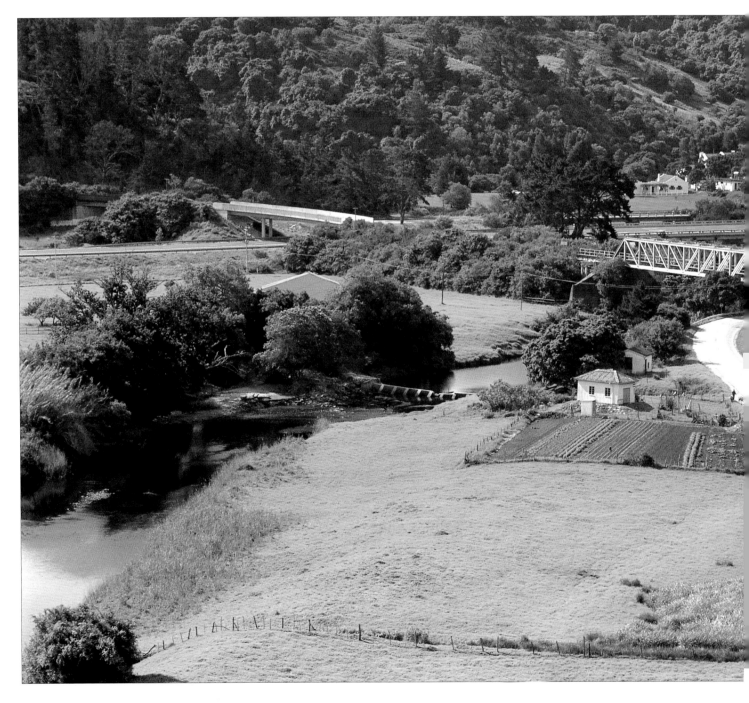

⛏ Opposite far left: *Visitors to the 'Lake District' have the option of accommodation in elegant country establishments, such as the Lake Pleasant Hotel at Groenvlei.* Opposite right: *The Wilderness National Park is the result of a successful experiment allowing recreational, commercial and agricultural enterprises to co-exist with a high level of conservation.* Below: *East of the lakes, en route to Knysna, the Goukamma River Valley resembles a corner of England in the heart of South Africa.* Below right: *Today, smaller game, such as zebra and 150 bird species (including the Knysna lourie), inhabit the reserves in the Buffalo Valley, once the home of buffalo and elephant.* Bottom right: *The Khoi name* Goukamma *describes the river's dark waters.*

▬ Ganz links: *Elegante Landgasthöfe, wie das Lake Pleasant am Gronvlei, bieten den Besuchern der Seenplatte schöne Unterkunftsmöglichkeiten.* Links: *Der Wilderness-Nationalpark ist ein von Erfolg gekrönter Versuch, Freizeit, Handel und Landwirtschaft mit Umweltschutz in Einklang zu bringen.* Links unten: *Östlich der Seen, in Richtung Knysna, meint man im Tal des Goukamma ein Fleckchen englischer Landschaft gefunden zu haben.* Rechts unten: *Das Naturschutzgebiet im Buffalo Valley ist heute die Heimat von kleineren Wildarten, wie zum Beispiel von Zebras sowie von 150 verschiedenen Vogelarten, so auch des Knysna Lourie (Helmturako).* Rechts, ganz unten: *Der Name Goukamma kommt aus der Sprache der Khoisan und beschreibt das dunkle Wasser dieses Flusses.*

🇫🇷 Ci-contre, en haut à gauche: *L'élégant hôtel Lake Pleasant à Groenvlei est un des gîtes disponibles aux visiteurs à la région des lacs.* Ci-contre, en haut à droite: *Le Parc National de Wilderness bénéficie d'une heureuse coexistence entre les activités de loisir, commerciales et agricoles, et un haut niveau de conservation.* Ci-dessous, à gauche: *A l'est des lacs, la vallée de la rivière Goukamma ressemble à un coin d'Angleterre perdu en Afrique du Sud.* Ci-dessous: *La Buffalo Valley (vallée des buffles), autrefois le home du buffle et de l'éléphant, contient maintenant des zèbres et 150 espèces d'oiseaux, y compris le lourie de Knysna.* En bas: *'Goukamma', un nom Khoi, décrit les eaux noires de la rivière du même nom.*

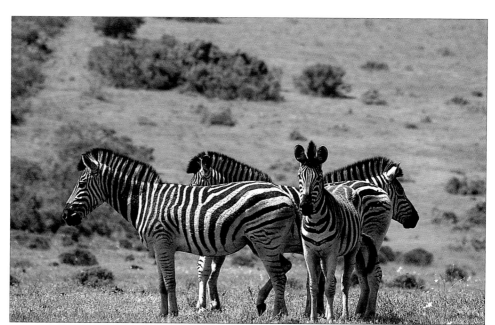

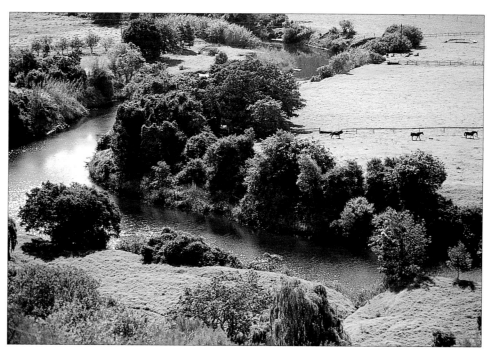

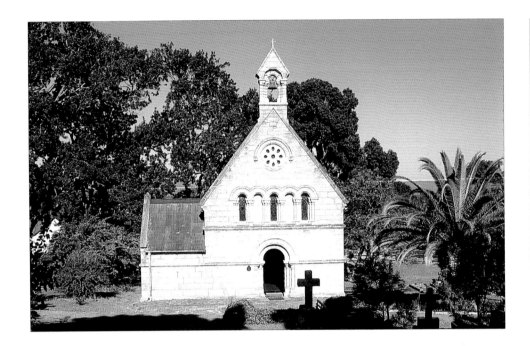

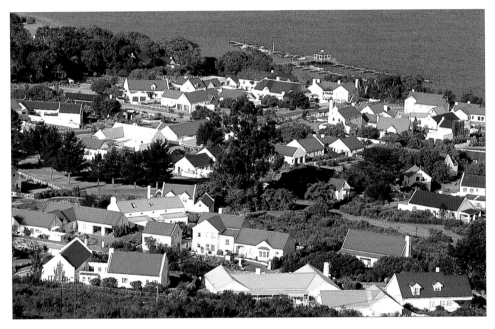

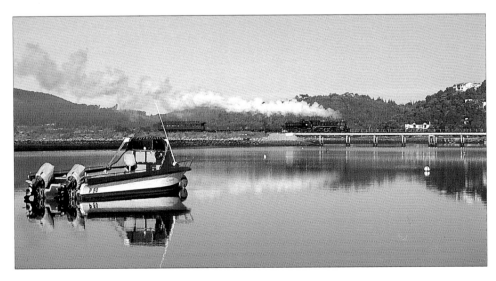

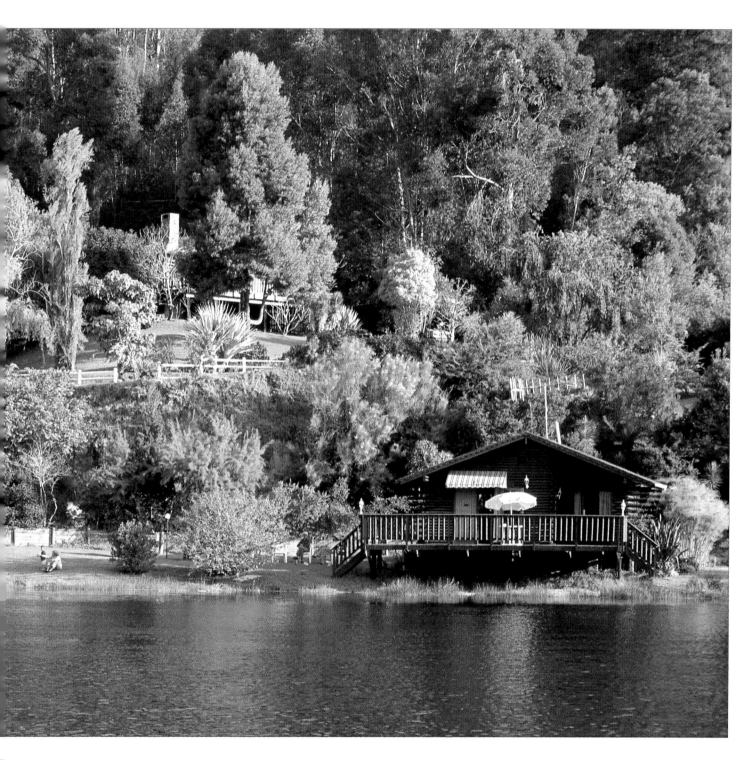

One of Knysna's most exclusive country-style developments, Belvidere lies on the west bank of the lagoon. Opposite top: The Lilliputian church at Belvidere, built in 1850 on the lines of an eleventh century Norman church, is still in use for special ceremonies. Opposite centre: The Belvidere lifestyle is luxurious and leisured. Opposite bottom: The Outeniqua Choo-Tjoe bustles across the lagoon as it has done, in all weathers, twice daily since 1928. Above: Luxuriant stands of largely indigenous trees line the banks of the Knysna River in the heart of the most intensively afforested region of South Africa.

Das im Landhausstil gehaltene Belvidere am westlichen Ufer der Lagune ist eines der modernsten Projekte in Knysna. Links oben: Die winzige Kirche in Belvidere, die 1850 im romanischen Stil des 11. Jahrhunderts erbaut wurde, wird zu besonderen Feierlichkeiten noch genutzt. Links Mitte: Der Lebensstil in Belvidere ist luxuriös und geruhsam. Links unten: Der Outeniqua Tschu-Tschu fährt seit 1928 bei jedem Wetter zweimal täglich schnaufend seine Route über die Lagune. Oben: Die Ufer des Flusses Knysna sind mit herrlichen, meist einheimischen Bäumen bestanden; es ist das Herzstück des größten und üppigsten Forstgebiets in Südafrika.

Un des développements les plus recherchés de Knysna, le Belvidere, est situé sur la rive ouest de la lagune. Ci-contre, en haut: L'église lilliputienne de Belvidere fut érigée en 1850 dans le style normand de l'onzième siècle. Elle sert toujours pour les occasions spéciales. Ci-contre, au centre: Le mode de vie luxueux et paisible au Belvidere. Ci-contre, en bas: L'Outeniqua Choo-Tjoe traverse en hâte la lagune, comme il l'a fait depuis 1928, par tous les temps. Ci-dessus: La rivière Knysna, au coeur de la région la plus boisée de l'Afrique du sud; la majorité des arbres couvrant ses berges luxuriantes sont indigènes.

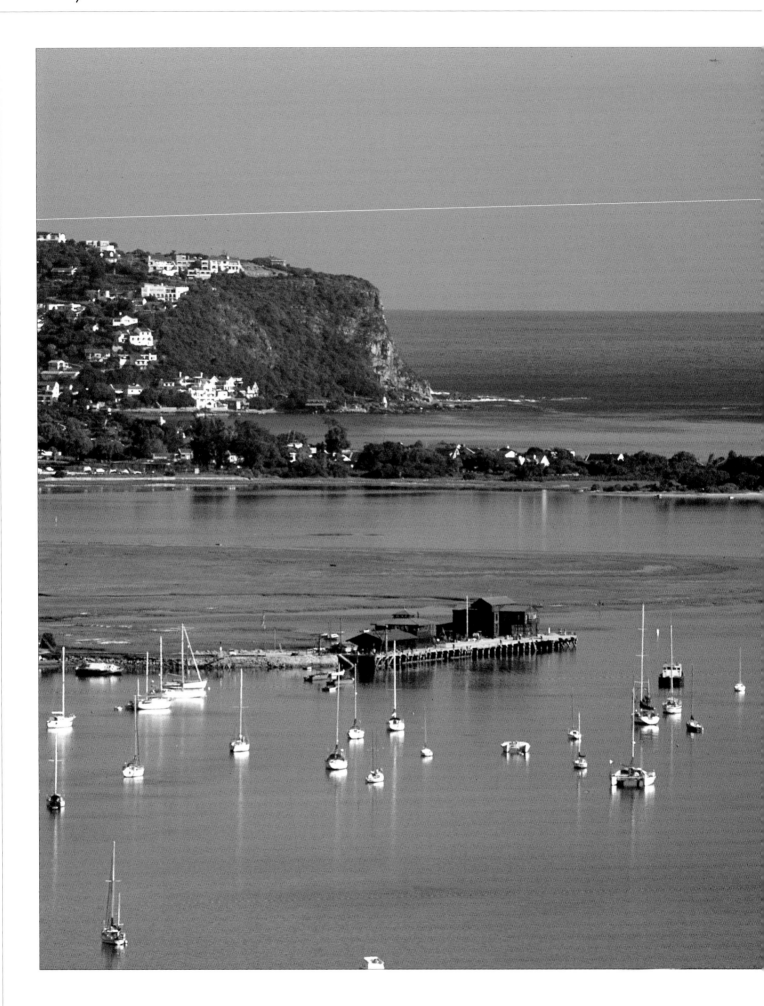

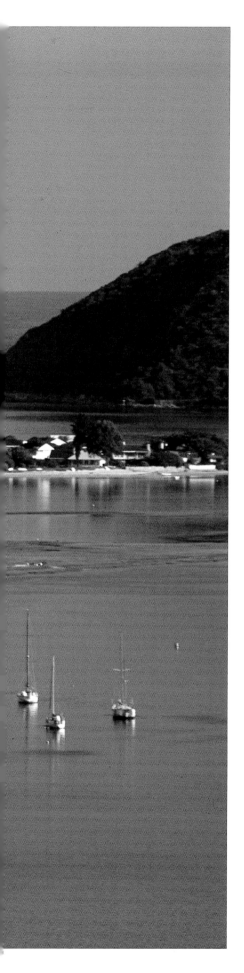

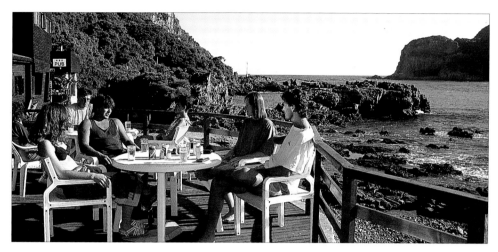

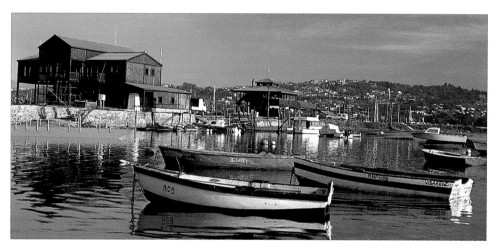

Left: *Holiday homes scramble over the sandstone sea cliffs, The Heads, meeting place between the Knysna Lagoon and the ocean. Knysna is at the heart of the protected Knysna National Lake Area. South Africa's largest river mouth, the 13-kilometre-square lagoon provides endless recreation opportunities and is home to a large oyster-farming enterprise. Taverns serving tapas and oysters with local ale line the eastern banks.* Top: *A few friends, some local ale and the low rays of the sinking sun. Where better to enjoy this happy combination than the terrace of a restaurant at The Heads?* Above: *Knysna Lagoon, once a harbour for whaling and logging vessels, still serves the timber and fishing industries. The town is an important centre for boat-building and the manufacture of furniture from indigenous woods.*

Links: *Ferienhäuser liegen verstreut auf den Sandsteinfelsen, The Heads genannt, wo die Lagune von Knysna in den Ozean mündet. Knysna ist das Herz des geschützten Knysna-National-Lake-Area. Es ist die größte Flußmündung Südafrikas, und die 13km große Lagune bietet zahllose Freizeitaktivitäten an und ermöglicht auch eine große, kommerzielle Austernzucht. Das ganze Dorfleben dreht sich um die Lagune. Die östlichen Ufer werden von Kneipen gesäumt, wo der Besucher Muscheln und Austern und vor Ort gebrautes Bier genießen kann.* Ganz oben: *Sonnenuntergang mit Freunden bei einem Glas Bier – wo kann man dies mehr genießen als auf der Terrasse eines Restaurants auf den Heads?* Oben: *Die Lagune von Knysna, einstmals Hafen für Walfänger und Holzfrachter, dient noch immer der Fisch- und Holzindustrie. Die Stadt ist ein wichtiges Zentrum für die Holzverarbeitung der schönen, einheimischen Bäume.*

A gauche: *Les villas s'accrochent aux falaises de grès, les Heads, où la lagune de Knysna et l'océan se rencontrent. Knysna est située au coeur du Knysna National Lake Area. La lagune, qui est la plus grande embouchure de rivière en Afrique du Sud, s'étend sur 13 kilomètres carrés. Elle offre une infinité d'activités récréatives et est le site d'un important élevage d'huîtres. La lagune est au centre de la vie du village. Des tavernes servant des tapas et des huîtres avec de la bière locale, bordent la rive est.* En haut: *Quelques bons amis, une bière du pays et les rayons du soleil couchant. Où mieux que la terrasse d'un restaurant aux 'Heads' pour savourer cette heureuse association?* Ci-dessus: *La lagune de Knysna, autrefois un port baleinier et pour les exportateurs de bois, est toujours en service pour les industries du bois et de la pêche. La ville est un centre important de construction navale et de fabrication de meubles en précieux bois indigènes.*

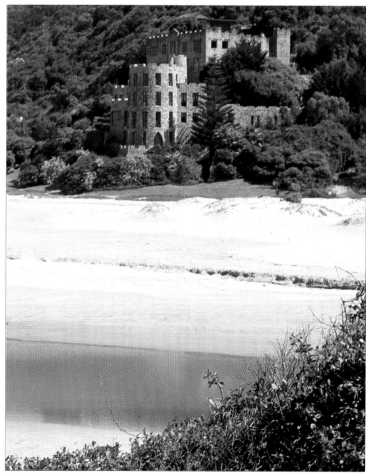

Left and bottom left: *Knysna attracts large numbers of crafters whose wares are sold from quaint venues in town and out: pottery, woodcarving, fynbos and wild flower honey, art, batik and leatherware.* Opposite bottom left: *Fine carpentry lives on in Knysna.* Opposite bottom right: *Even the well-dressed dog will find something to wear at the open-air market.* Below: *For all of us, our home is our castle – for the wealthy Henderson family of Zimbabwe, this extended to their seaside homes. Built in 1932, their stone 'castles' are landmarks at Noetzie, accessible only to the determined, via a series of steps and a torturous footpath.*

Links und links unten: *In Knysna lebt eine große Anzahl Menschen, die im Kunstgewerbe tätig sind. Sie bieten ihre Erzeugnisse an malerischen Standorten feil: Töpferarbeiten, Gemälde, Holzschnitzereien, Honig aus Fynbos und Wiesenblumen sowie Lederwaren sind überall erhältlich.* Unten, ganz links und Mitte: *Es gibt noch heute schöne Holzarbeiten in Knysna, wohl ein Erbe der alten Holzfäller. Auch ein modebewußter Hund kann auf dem Straßenmarkt etwas Passendes finden.* Unten: *Für einen jeden von uns ist sein Heim eine Burg – für die wohlhabende Hendersonfamilie aus Simbabwe bezieht sich dies auch auf ihre Ferienhäuser am Meer. Ihre 'Steinburgen', 1932 erbaut, sind Wahrzeichen des Strandes Noetzie, der kurz hinter Knysna liegt.*

A gauche et ci-dessous à gauche: *Knysna attire de nombreux artistes et artisans qui vendent leurs créations dans des endroits pittoresques, aussi bien en ville que dans ses abords: poteries, sculptures, miel de fleurs sauvages et fynbos, batik et cuirs ouvragés sont disponibles en quantité.* Ci-contre, en bas, à gauche et à droite: *Knysna possède de nombreux ébénistes réputés, successeurs, sans doute, des bûcherons d'autrefois. Même le chien le plus raffiné trouvera de quoi s'habiller au marché en plein air.* Ci-dessous: *Les villas de vacances des Henderson, une famille du Zimbabwe. Leurs 'châteaux' de pierre, construits en 1932 sur la plage de Noetzie, ne sont accessibles qu'aux plus persistants, car, pour y arriver, il faut emprunter de nombreux escaliers et un sentier sinueux.*

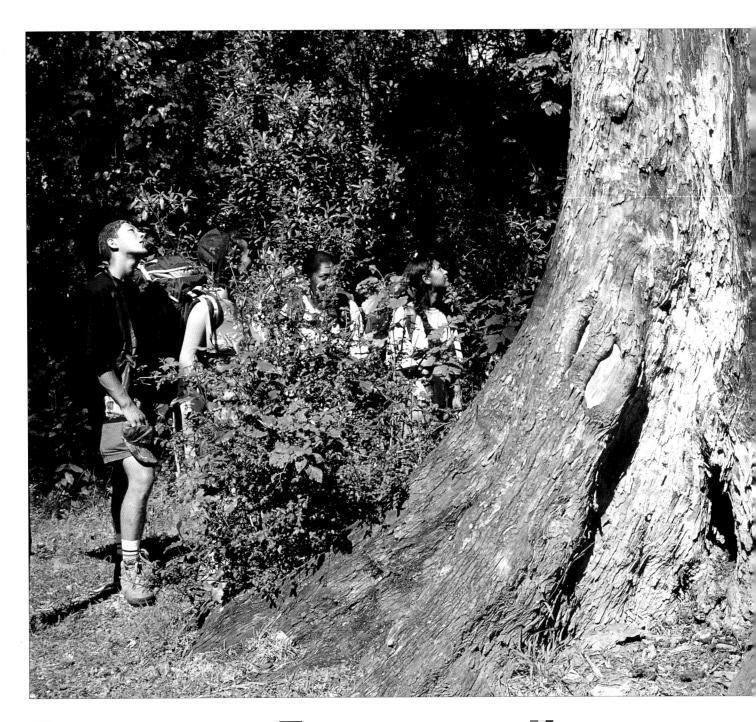

Above: *Yellowwood trees, such as this Outeniqua yellowwood* (Podocarpus falcatus) *were once prolific in the coastal forests. The most common species now is the ironwood* (Olea capensis). Opposite bottom left: *Ericas add vivid colour to the abundant* fynbos *along the Garden Route.* Opposite top: *Knysna's 'gold rush' in the 1870s left relics of a briefly booming mine town, Millwood, in the heart of the Tsitsikamma at Jubilee Creek. Millwood House was dismantled and reassembled in town, where it is a charming museum.* Opposite centre: *Old mineshafts and equipment are being restored in an ambitious project to recreate the Millwood of the nineteenth century, complete with original machinery.* Opposite bottom right: *Jubilee Creek is now a tranquil picnic spot.*

Oben: *Gelbholzbäume wie dieser* Podocarpus falcatus *prägten einst das Bild des Küstenwaldes. Die häufigste Spezie ist heute der* Olea capensis. Rechts: *Entlang der der Garden-Route findet man* Fynbos, *der von farbenprächtiger Erika untermalt wird.* Rechts oben: *Nach dem Goldrausch in Knysna um 1870 wurde Millwood House auf dem Minengelände abgetragen und in der Stadt wieder aufgebaut, wo es ein bezauberndes Museum abgibt.* Rechts Mitte: *In einem ehrgezeigen Projekt werden die alten Minenschächte und -ausrüstungen restauriert, um das Millwood des 19.Jahrhunderts mit seinen ursprünglichen Maschinen wieder erstehen zu lassen.* Rechts unten: *Der Fluß Jubilee Creek ist heutzutage ein wunderschöner Ort, um Picknicke zu veranstalten.*

Ci-dessus: *Les yellowwoods tel que cet Outeniqua yellowwood* (Podocarpus falcatus) *étaient trouvés jadis en abondance. L'espèce la plus commune est le ironwood* (Olea capensis). Ci-contre, en bas à gauche: *Les ericas ajoutent leurs couleurs vives à l'abondant* fynbos *tout au long de la Route des Jardins.* Ci-contre, en haut: *Millwood, au coeur du Tsitsikamma est le vestige d'une ville minière établie dans les années 1870. Après une brève ruée vers l'or, Millwood House fut démontée et reconstruite dans le village, où elle est maintenant un charmant musée.* Ci-contre, au centre: *Les vieux puits de mines et l'outillage sont restaurés dans un ambitieux projet qui recréera le Millwood du dix-neuvième siècle.* Ci-contre, en bas: *Aujourd'hui Jubilee Creek est un paisible pique-nique* .

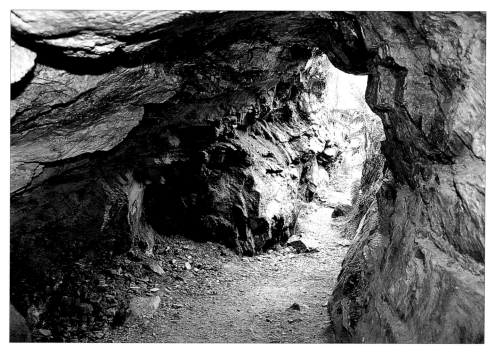

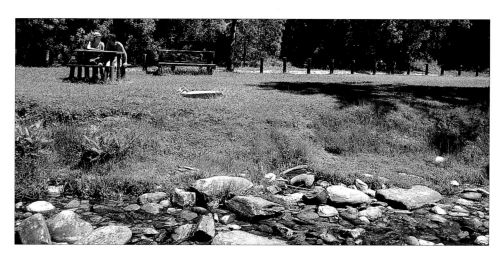

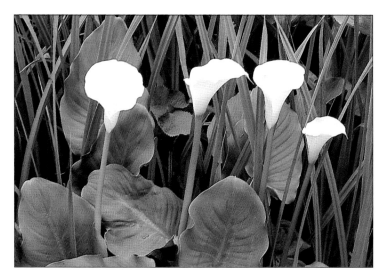

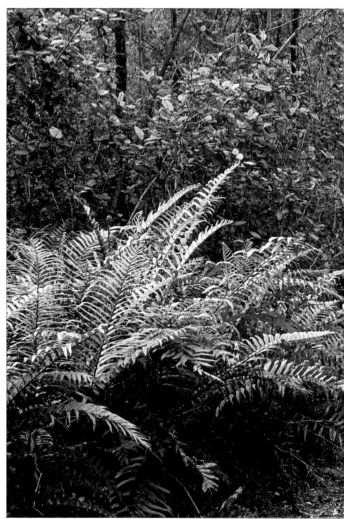

Top right: *The stretch from Knysna to Plettenberg Bay includes some of the most romantic reaches of the great coastal forests, with evocative names such as the Garden of Eden and the Valley of Ferns. The forest canopy at Gouna is so dense that the sky is obscured.* Top: *Fungi thrive in the humus of the forest floor.* Above: *Every moist nook reveals a showy cluster of elegant arum lilies.*

Oben rechts: *Auf der Strecke zwischen Knysna und Plettenberg Bay trifft man auf romantische Waldgebiete mit fantasievollen Namen wie 'Garten Eden' und 'Tal der Farne'. Das Blätterdach bei Gouna ist so dicht, daß man den Himmel nicht sehen kann.* Ganz oben: *Große Pilze gedeihen im Humus des Waldbodens.* Oben: *In jeder feuchten Ecke des Waldes blühen die elganten, strahlend weißen Kallalilien.*

En haut à droite: *La région forestière entre Knysna et Plettenberg Bay est une des plus romantiques des grandes forêts côtières, avec des noms évocateurs comme 'Garden of Eden' (Paradis Terrestre) et 'Valley of the Ferns' (Vallée des Fougères). A Gouna, la voûte de la forêt est tellement épaisse qu'elle cache le ciel.* En haut: *Les champignons abondent dans l'humus de la forêt.* Ci-dessus: *Chaque petit coin humide révèle un bouquet de lis élégants.*

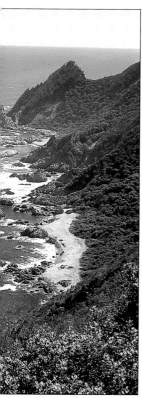

Opposite bottom: *Soaring cliffs and pounding surf at Kranshoek near Plettenberg Bay. The nearby village of Kranshoek has been home to a settlement of about 1 000 Griqua people since 1928.* Below: *The George lily* (Cryanthus purpureus), *rare and stringently protected, is found only in the damp kloofs and crags of the mountains near George and Knysna.*

Unten links: *Aufragende Felsklippen und eine gewaltige Brandung bei Kranshoek, un- weit von Plettenberg Bay, faszinieren das Auge. Seit 1928 leben im Dorf Kranshoek etwa 1 000 Angehörige des Stammes Griqua.* Unten: *Die* Cryanthus purpureus, *eine äußerst seltene und geschüzte Pflanze, findet man nur auf feuchten Bergkämmen und Felsen bei George und Knysna.*

En bas à gauche: *Les vagues se fracassent au pied des falaises vertigineuses de Kranshoek, près de Plettenberg Bay. Le village de Kranshoek est la demeure de quelques 1 000 Griqua depuis 1928.* Ci-dessous: *Rare et rigoureusement protégé, le lis George* (Cryanthus purpureus) *n'est trouvé que dans les ravins humides et dans les crevasses des montagnes près de George et Knysna.*

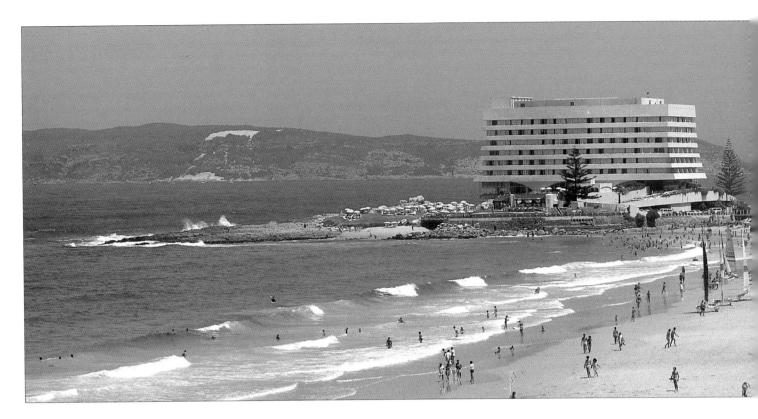

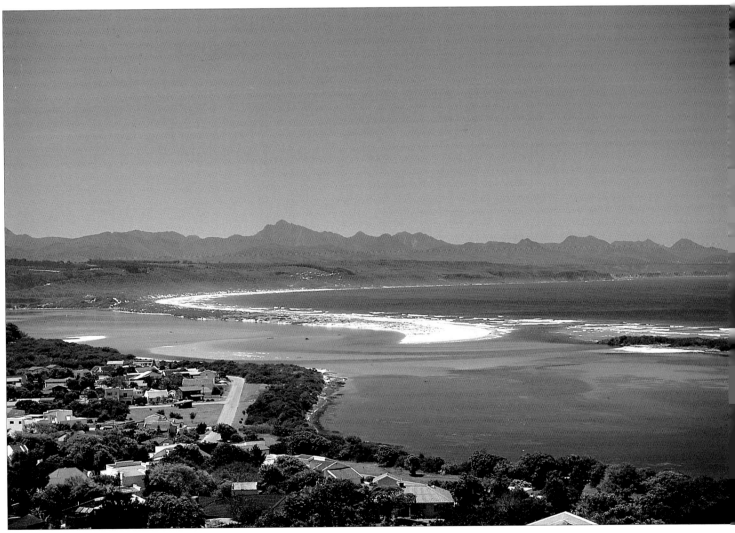

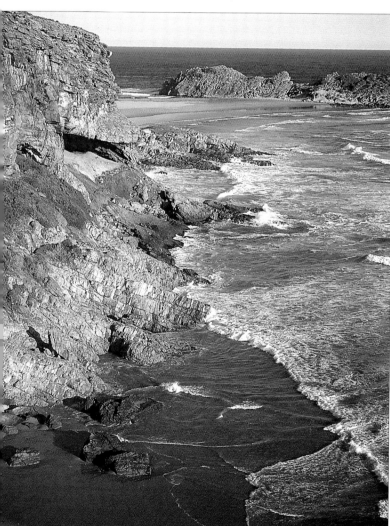

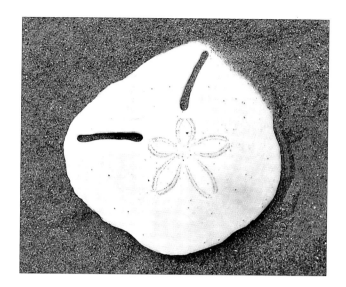

Top left: *Plettenberg Bay is perhaps the most fashionable of the Garden Route coastal resorts, its three beautiful beaches popular with pleasure-seekers. Its landmark resort hotel occupies a spectacular site on Beacon Isle, with endless Indian Ocean views. A fortress of luxury and leisure, the hotel is separated from the beach by a tidal 'moat', the languid Piesang River. Opposite bottom left: Stunning Lookout Beach lies back-to-back with the Bietou Lagoon, each offering superb recreational options for up-country sun-seekers who surge annually to 'Plett' for a blissful holiday. Bottom left: Robberg Peninsula forms the western arm of the bay and is an important archaeological site, with relics dating to 700 BC displayed in Nelson's Cave. Above: Symbol of Plettenberg Bay, the rare and delicate pansy shell* (Echinodiscus bisperforatus).

Links oben: *Plettenberg Bay, sicherlich der mondänste Ferienort an der Küste der Garden Route, hat drei herrliche und sehr beliebte Badestrände. Sein Wahrzeichen ist das Ferienhotel auf Beacon Isle, das auf die Weite des Indischen Ozeans blickt. Das Hotel ist eine Stätte des Luxus und der Erholung und wird durch seinen eigenen 'Gezeitengraben', dem gemächlich dahinfließenden Piesang vom Strand getrennt. Ganz links: Der atemberaubende Lookout Beach grenzt an die Bietou Lagune; Sonnenanbeter aus dem Inland lieben beide. Links: Die Halbinsel Robberg, die unter Naturschutz steht, bildet den westlichen Arm der Bucht und ist eine bedeutende archäologische Stätte, deren Funde bis 700 v.Chr. zurückdatieren und in der Nelson's Cave ausgestellt werden. Oben: Das Wahrzeichen von Plettenberg Bay ist die seltene und zierliche Muschel, die* Echinodiscus bisperforatus.

En haut à gauche: *Plettenberg Bay est la station balnéaire la plus branchée de la Route des Jardins. Elle offre trois splendides plages, toutes populaires. Son hôtel le plus éminent occupe un site spectaculaire sur Beacon Isle (île Balise), avec des vues panoramiques sur l'océan Indien. Luxueuse citadelle de loisirs, l'hôtel est séparé de la plage par une 'douve', la languissante rivière Piesang (rivière des bananes). Ci-contre, en bas à gauche: La sensationnelle Lookout Beach (plage du poste de guet) est située dos à dos avec la lagune de Bietou, chacune offrant une variété de passe-temps pour les visiteurs de l'intérieur qui, annuellement, envahissent 'Plett' à la recherche des vacances parfaites. A gauche: La péninsule de Robberg, à l'extrémité ouest de la baie, est un site archéologique. Des vestiges datant de 700 av. JC sont exposés dans Nelson's Cave (la grotte de Nelson). Ci-dessus: Le symbole de Plettenberg Bay est le rare et fragile 'pansy shell' – coquillage pensée* (Echinodiscus bisperforatus).

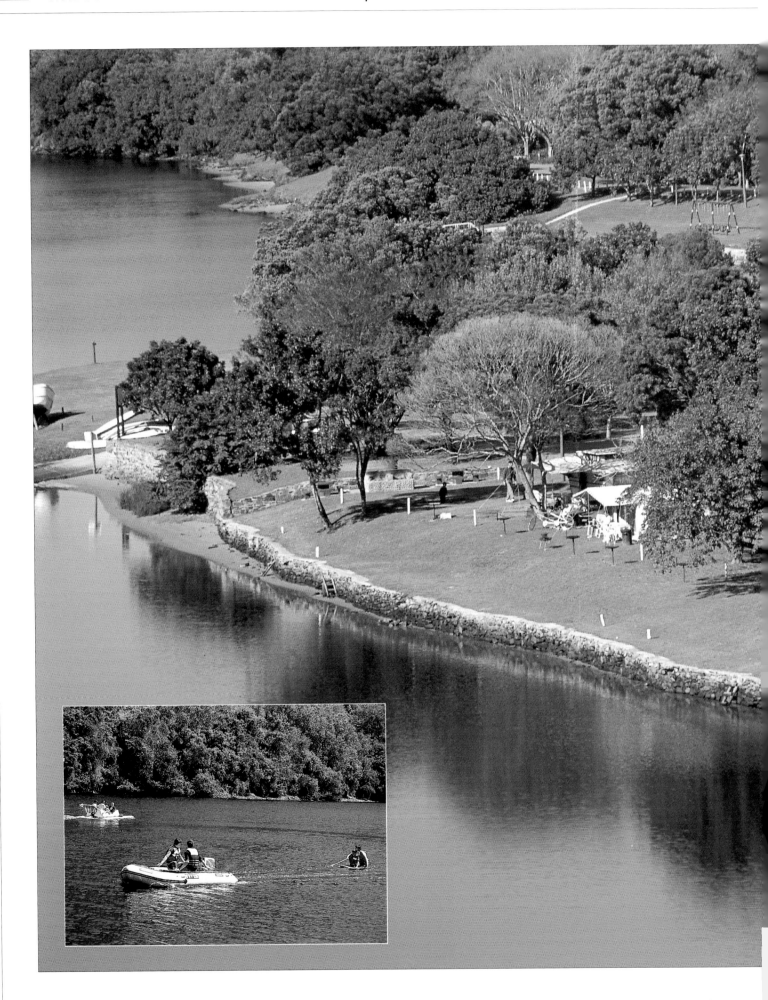

Left: *Keurbooms River's lagoonside resort makes provision for camping and caravanning, with excellent facilities and well-kept lawns. Fully equipped log cabins may also be hired.* Inset: *The Keurbooms, unlike many Garden Route rivers, has its source many kilometres away, between the Outeniquas and the Tsitsikammas. The clean brown river provides endless spaces for enjoyment on its broad, gentle passage to the sea.* Below: *A landmark at Keurboomstrand – the cathedral-sized arch of rock sculpted by the passage of the sea. Other relics, some 11 000 years old, can be found at nearby Matjies River Cave, where a huge midden has yielded thousands of valuable objects that are helping archaeologists piece together the puzzle of South Africa's primeval people.*

Links: *Der Ferienort an der Lagune des Keurbooms ist ein wunderschöner Camping- und Wohnwagenplatz, derbestens mit ausgestattet ist.* Einsatz: *Im Gegensatz zu vielen anderen Flüssen der Garden-Route, die nur einen Lauf von 10 Kilometern oder weniger haben, liegt die Quelle des Keurbooms weit entfern zwischen den Outeniqua- und den Tsitsikammabergen. Der braune, aber saubere Fluß ist durch seine Breite und die träge Strömung ein ideales Freizeitgebiet.* Unten: *Eine Landmarke am Strand Keurboom: Der Felsbogen, der der Größe einer Kathedrale entspricht, wurde durch das Meer gerformt. Relikte, von denen einige 11 000 Jahre alt sind, kann man in der nahegelegenen Matjies-River-Cave finden, wo aus einem riesigen Muschelberg tausende wertvoller Gegenstände zutage gefördert wurden, die den Archäologen helfen, Fragen über das Leben der Ureinwohner Südafrikas zu lösen.*

A gauche: *Le terrain de camping et de caravaning sur les bords de la lagune de la rivière Keurbooms est très bien aménagé et possède de splendides pelouses. Il est aussi possible de louer des chalets tout équipés.* En cartouche: *La source de la Keurbooms se trouve entre les montagnes de l'Outeniqua et de Tsitsikamma. Ses eaux brunes, mais propres, offrent tout au long de son parcours vers la mer, de nombreux endroits pour se délasser.* Ci-dessous: *Une curiosité à Keurboomstrand: le rocher que la mer a sculpté en forme d'arc-boutant de cathédrale. D'autres vestiges, certains vieux de 11 000 ans, se trouvent à Matjies River Cave (la grotte de la rivière des roseaux), où il y a un énorme ancien dépotoir où ont été découverts des milliers d'objets qui ont permis aux archéologues de percer l'énigme des peuples primitifs de l'Afrique du Sud.*

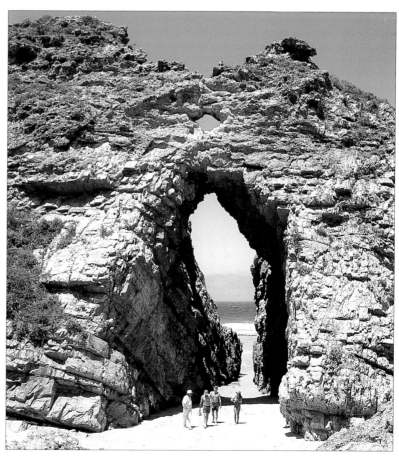

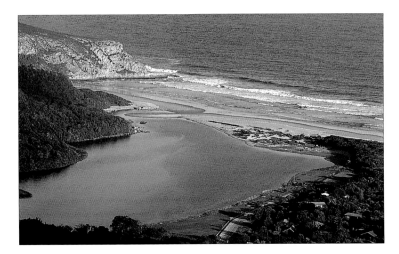

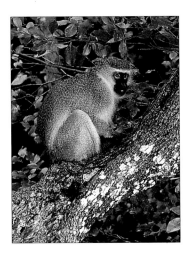

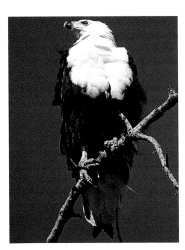

Right: *The Nature's Valley resort, with holiday homes like this timber tree house, is part of the small, lovely De Vasselot Reserve.* Top: *The Bloukrans Lagoon is a landmark of the Otter Trail, a five-day hike starting at Nature's Valley, a premier attraction of the Tsitsikamma National Park.* Above left: *Vervet monkeys* (Cercopithecus aethiops) *are among the park's diverse inhabitants.* Above right: *The African fish eagle* (Haliaeetus vocifer) *is found around the larger rivers, lakes, pans, lagoons and estuaries of southern Africa. Chiefly a fish eater, it also eats carrion and water birds, especially nestlings and eggs.*

Rechts: *Der Erholungsort Nature's Valley, wo es hölzerne Ferienwohnungen gibt, ist Teil des Naturschutzgebiets De Vasselot.* Ganz oben: *Die Bloukrans-Lagune ist ein Landmark des Otter Trail, einer bekannten Wanderroute, die über fünf Tage an der Küste entlangführt. Dieser Wanderweg ist eine der Hauptattraktionen des Tsitsikamma-Nationalparks.* Oben links: *Grünmeerkatzen* (Cercopithecus aethiops) *gehören zu den verschiedenen Bewohnern des Parks.* Oben rechts: *Der afrikanische Schreiseeadler* (Haliaeetus vocifer) *wird im Umkreis der Flüsse, Seen, Salzpfannen, Lagunen und Ästuarien des südlichen Afrika angetroffen. Er ist überwiegend ein Fischfresser, verzehrt aber auch Aas und Wasservögel, wobei er sich besonders an Nestlinge und Eier hält.*

A droite: *Le centre de vacances de Nature's Valley comprend des bungalows, comme cette cabane, faisant partie de la petite réserve De Vasselot.* En haut: *La lagune de Bloukrans est un des points saillants de l'Otter Trail – une des meilleures attractions du Parc National de Tsitsikamma – une randonnée de cinq jours, qui prend son départ à Nature's Valley.* Ci-dessus à gauche: *Quelques-uns des habitants du parc: les vervets* (Cercopithecus aethiops). Ci-dessus à droite: *L'aigle pêcheur* (Haliaeetus vocifer) *fréquente les rivières, lacs, lagunes et estuaires de l'Afrique australe. Il se nourrit principalement de poisson, mais aussi de charogne et d'oiseaux aquatiques, spécialement les oisillons et les oeufs.*

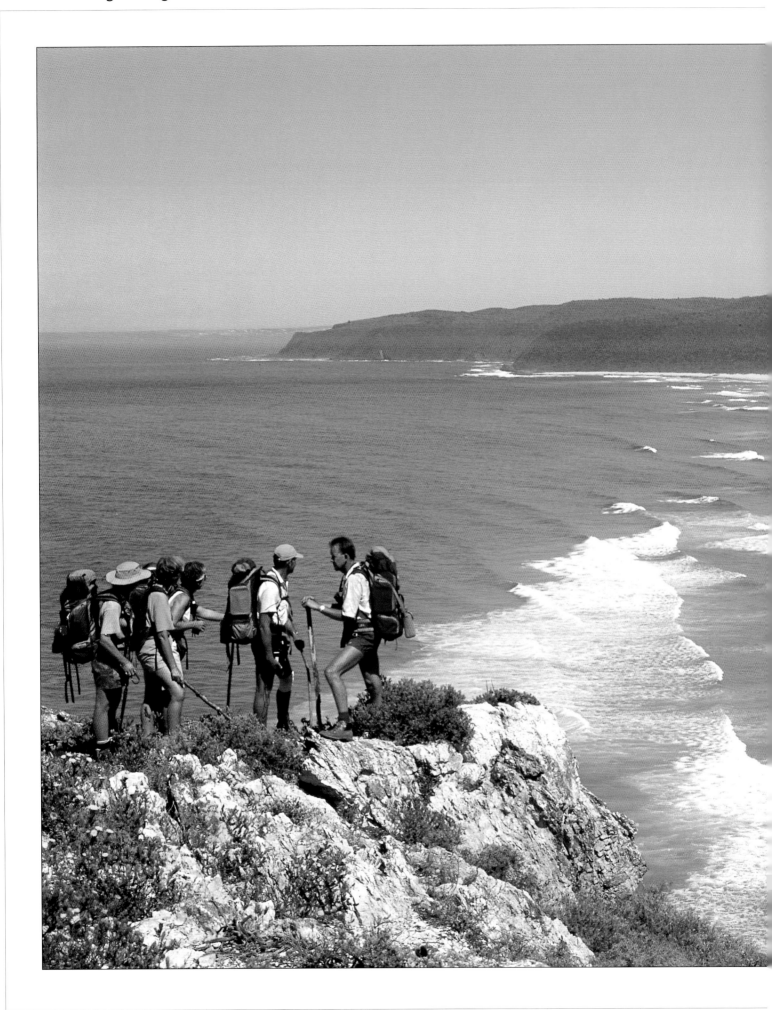

Left: *The Tsitsikamma trails take hikers through a superb diversity of coastal scenery. Information on hikes in all categories – from a few hours to a few days – is supplied at the Storms River Mouth rest camp and the De Vasselot Reserve at Nature's Valley, which jointly offer 11 trails.* Below: *Restios (Cape reeds) and protea juxtaposed in natural profusion. These are just two of the 7 300 species of plants richly represented along the western and southern coastal areas. Of these, 5 000 do not occur anywhere else in the world and many are in danger of extinction.* Fynbos *consists chiefly of evergreen shrubs with tough, leathery leaves which prevent dehydration in wind and heat. Although* fynbos *cannot support game, it attracts birds, insects and smaller animals.*

Links: *Abwechslungsreiche Wanderwege führen durch die zauberhafte Landschaft des Tsitsikamma. Informationen über die verschiedenen Wanderungen, die einige Stunden oder Tage dauern können, kann man bei dem Rastlager an der Mündung des Storms River einholen sowie im De-Vasselot-Reservat in Nature's Valley, die gemeinsam 11 verschiedene Wanderungen anbieten.* Unten: *Restios (Schilf) und Proteen gedeihen in natürlicher Üppigkeit. Sie sind nur zwei der 7 300 Pflanzenarten, die an der westlichen und südlichen Küste des Kaps gedeihen. 5 000 dieser Pflanzen gibt es an keinem anderen Ort der Welt, und viele sind in Gefahr auszusterben.* Fynbos *besteht meist aus Sträuchern, die harte, lederige Blätter haben, die sie bei Wind und Hitze vor dem Austrocknen schützt. Diese Pflanze lockt Vögel, Insekten und kleinere Tiere an.*

A gauche: *Toutes très différentes, les pistes du Tsitsikamma conduisent les randonneurs dans les splendeurs de la région côtière. Les informations nécessaires sont disponibles au camp de l'embouchure de la rivière Storms, et à la réserve De Vasselot à Nature's Valley. Conjointement, ils offrent un choix de 11 randonnées.* Ci-dessous: *Restios (roseaux du Cap) et protées foisonnent. Ceux-ci ne sont que deux espèces parmi les 7 300 plantes qui abondent dans ces régions côtières. De celles-ci, 5 000 n'existent nulle part ailleurs au monde, et nombreuses sont celles en voie d'extinction. Le* fynbos *consiste principalement de buissons à feuilles persistantes très résistantes, empêchant la déshydratation. Le* fynbos *attire les oiseaux, les insectes et les petits animaux.*

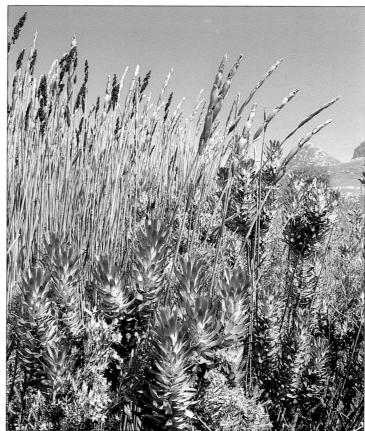

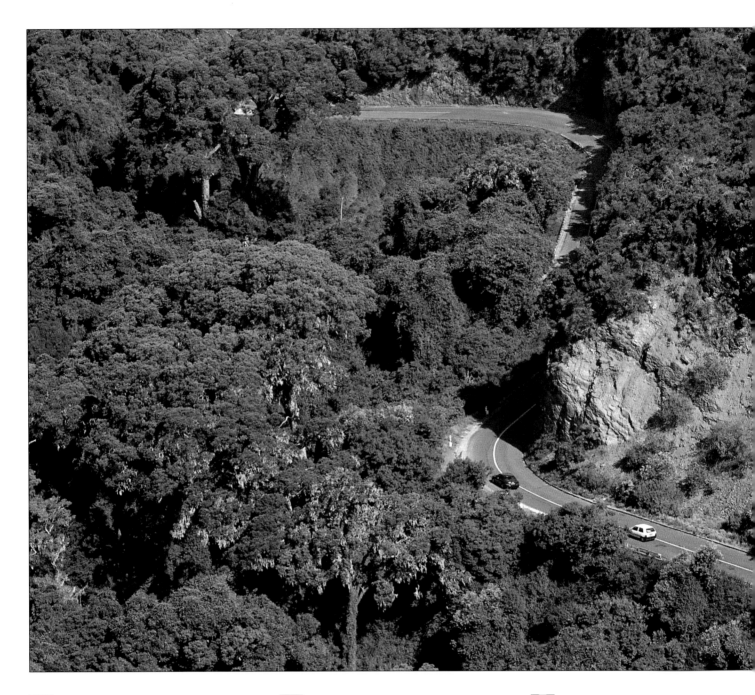

Above: *Travelling through an almost continuous tunnel of vegetation, the Grootrivier Pass – a spectacular scenic alternative to the toll highway – drops into Nature's Valley through the De Vasselot Reserve. The Bloukrans Pass further east is equally lovely. The toll highway traverses three arched bridges, supreme achievements of modern engineering, with Bloukrans particularly noteworthy as the longest single-span concrete bridge in the world. Opposite top: The 'Big Tree' in the Garden of Eden near Knysna is an 800-year-old Outeniqua yellowwood (Podocarpus falcatus), seven metres in circumference and with a 46-metre-high trunk. Opposite bottom: Evergreen and riverine forests are ideal habitats for the handsome Knysna lourie (Tauraco corythaix). The Knysna forests are the birds' southernmost habitat.*

Oben: *Man hat auf dem Grootrivier Paß das Gefühl, man wandere durch einen Pflanzentunnel, der dann durch das Forstschutzgebiet De Vasselot bis nach Nature's Valley führt. Der Bloukrans Paß, weiter östlich gelegen, ist von ähnlicher Schönheit. Die Fernstraße führt über drei Bogenbrücken, die hervorragende Beispiele moderner Ingenieurskunst sind, und besonders die Bloukransbrücke ist beachtenswert, da sie die längste Einzelbogenbrücke aus Beton ist. Rechts oben: Der 'Große Baum' im Garden of Eden bei Knysna ist ein 800jähriger* Podocarpus falcatus *von sieben Metern Durchmesser und einer Höhe von 46 Metern. Rechts unten: Immergrüne Flußwälder sind ein ideales Habitat für den prachtvollen, endemischen Knysna Lourie (Tauraco Corythaix). Die Wälder bei Knysna sind die südlichste Ecke des Verbreitungsgebiets dieses Vogels.*

Ci-dessus: *Passant dans un interminable tunnel de végétation, la Grootrivier Pass (col de la grande rivière) – une route bien plus spectaculaire que l'autoroute à péage – descend dans Nature's Valley, par la réserve forestière De Vasselot. Plus à l'est, la Bloukrans Pass est tout aussi agréable. La route à péage emprunte trois ponts à arches, excellents exemples d'ingénierie moderne, dont le Bloukrans est particulièrement remarquable. Il est le plus grand pont en béton du monde à travée unique. Ci-contre, en haut: Le 'Big Tree' (grand arbre) du Garden of Eden près de Knysna est un Outeniqua yellowwood (Podocarpus falcatus) vieux de 800 ans; il fait sept mètres de circonférence et 46 de haut. Ci-contre, en bas: Les forêts riveraines et persistantes sont un habitat idéal pour le Knysna lourie (Tauraco corythaix). Ces forêts sont aussi l'habitat le plus austral de ces oiseaux.*

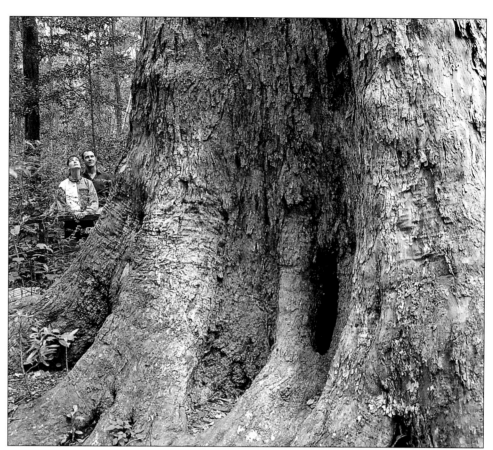

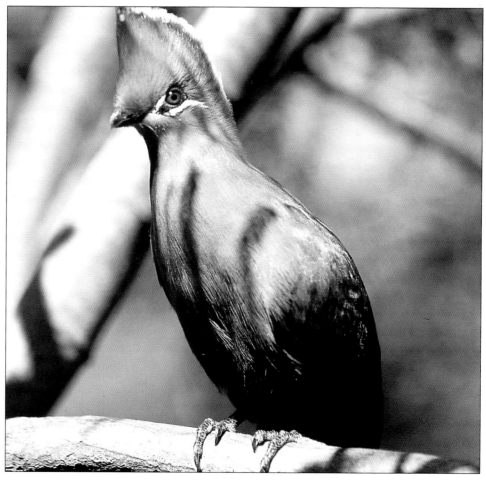

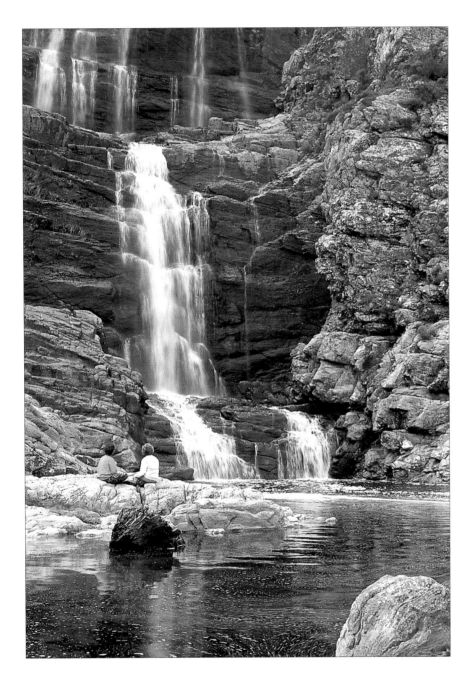

Above: *The Storms River waterfall rewards hikers on the Otter Trail, one of the natural splendours in store over 41 kilometres and the next five days. A singular reward could be the sighting of a Cape clawless otter fishing in the many rivers of the Tsitsikamma ('place of clear waters').* Top right: *Storms River Mouth, a turbulent meeting place of sea and river water, where jagged rocks with names like 'Skietklip' (shooting rock) throw white towers of sea spray many metres into the air (see picture on page 48).* Opposite bottom left: *Crossing the dark waters of the Storms River by suspension bridge is, for many visitors, a highlight of a visit to Storms River Mouth.* Opposite bottom right: *At the end of a day's hike, the timber chalets of the Storms River rest camp appear particularly hospitable. The camp has excellent facilities, including a camp site, restaurant and shop. Five trails have their starting place here.*

Oben links: *Der Wasserfall des Storms River, nur eines der Naturwunder auf den 41 Kilometern der Fünftageswanderung, belohnt die Wanderer des Otter Trail. Ein Höhepunkt ist der Anblick einer Kapfingerotter, die in den vielen Flüssen des Tsitsikamma (Ort der reinen Wassers) lebt.* Oben rechts: *Die Mündung des Storms River, ein turbulenter Begegnungspunkt von Meer und Fluß, wo an spitzen Felsen mit Namen wie 'Skietklip' (Schießklippe) weiße Gischtfontänen meterhoch in die Luft schießen (siehe Seite 48).* Rechts: *Die Hängebrücke, die über das dunkle Wasser an der Mündung des Storms River führt, ist für viele Besucher ein Abenteuer. Ganz rechts: Nach der Tageswanderung erscheinen die Holzhütten des Rastlagers noch einladender als sonst. Das Rastlager hat ausgezeichnete Sanitäranlagen sowie einen Zeltplatz, ein Restaurant und einen Laden. Fünf Wanderwege nehmen hier ihren Anfang.*

Ci-dessus à gauche: *Otter Trail: les chutes de la rivière Storms. Une des nombreuses merveilles de la nature réparties sur les 41 kilomètres de la piste. Une remarquable rencontre serait de voir une des loutres du Cap (elles n'ont pas de griffes), pêchant dans une des rivières du Tsitsikamma (l'endroit aux eaux claires).* Ci-dessus: *L'embouchure de la rivière Storms, un endroit de rencontre turbulent entre mer et rivière, là où des rocs déchiquetés aux noms tels que 'Skietklip' (le roc qui tire) projettent des colonnes d'eau à plusieurs mètres dans l'air (voir page 48).* Ci-contre, en bas à gauche: *Un des moments d'aventure lors d'une visite à l'embouchure de la rivière Storms.* Ci-contre, en bas à droite: *A la fin d'une journée de marche les accueillants chalets du camp de la rivière Storms vous attendent. Il y a un terrain de camping, un restaurant et des magasins. Cinq pistes de randonnées y prennent le départ.*

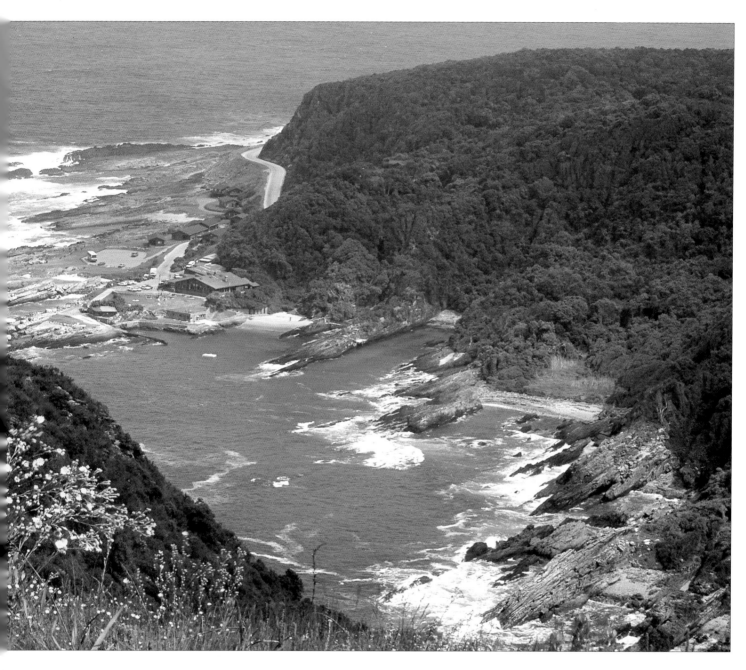

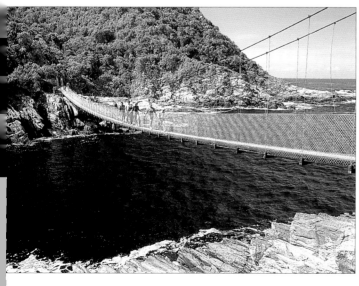

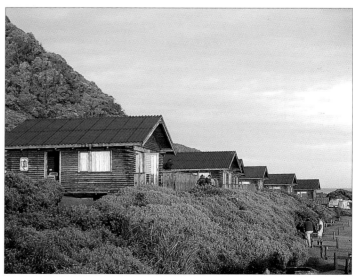

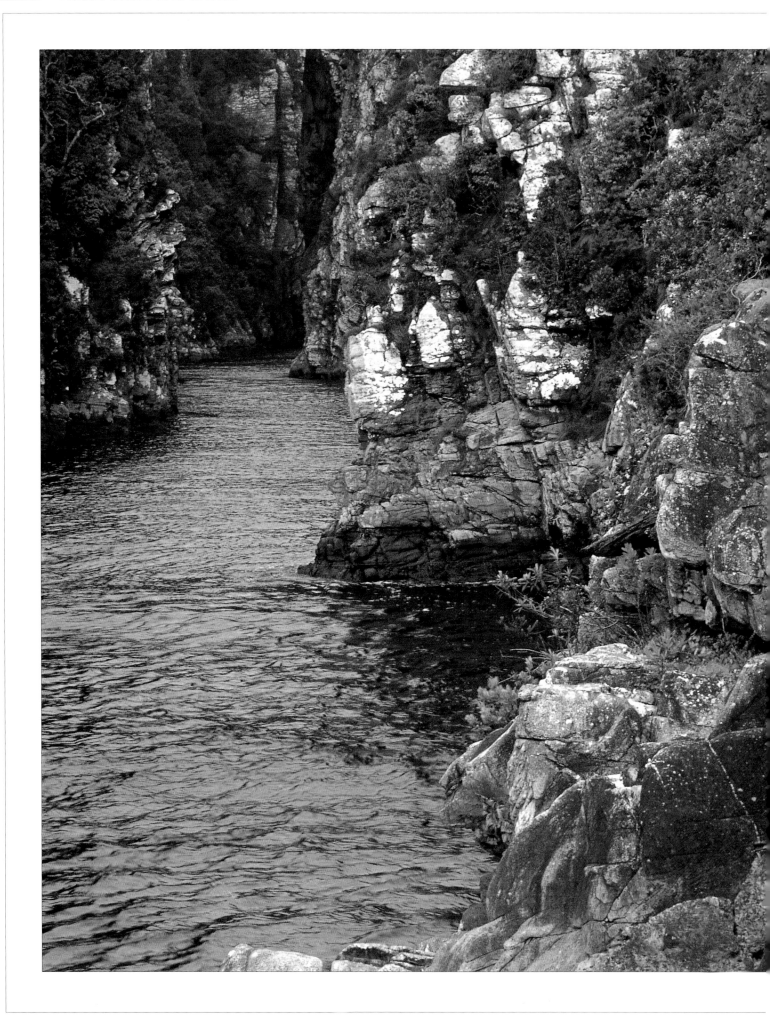

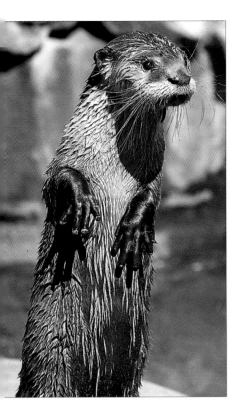

Opposite: *Snaking through a pristine ravine, the Storms River makes its way to the sea.* Left: *An endearing creature, the Cape clawless otter is rarely seen. More likely are sightings of blue duiker, bushbuck and Cape grysbok, while dolphins and whales are spotted offshore in winter. More than 200 species of bird have been recorded in the Tsitsikamma Coastal National Park.* Below: *The Paul Sauer Bridge spans the Storms River Gorge at the eastern gateway to the Garden Route. The construction caused a sensation in the mid-1950s when the two concrete arches, built like sections of a drawbridge, were lowered – and met without a centimetre to spare. There are spectacular views of the gorge from the restaurant complex, a picnic site on the fringe of the forest, and the pedestrian walkways on the bridge.*

Gegenüber: *Auf seinem Weg zum Meer windet sich der Storms River durch eine unberührte Schlucht.* Links: *Die Kapfingerotter, ein possierliches Tierchen, bekommt man selten zu Gesicht. Viel häufiger sieht man Blauducker, Buschböckchen und Grauböckchen; im Winter kann man Delphine und Wale vor der Küste ausmachen. Mehr als 200 Vogelarten sind im Tsitsikamma-Küstenschutzgebiet zuhause.* Unten: *Die Paul-Sauer-Brücke überquert die Schlucht des Storms River am östlichen Anfang der Garden-Route. Die Konstruktion war Mitte der 50er Jahre eine Sensation gewesen, als die beiden Brückenbögen, die man wie Teile einer Zugbrücke konstruierte, herabgelassen wurden und sich auf den Zentimeter genau zusammenfügten. Einen atemberaubenden Ausblick auf die Schlucht hat man vom Restaurant, einer Picknickstelle am Waldrand sowie dem Fußweg auf der Brücke aus.*

Ci-contre: *Serpentant dans un ravin, la rivière Storms se dirige vers la mer.* A gauche: *Une loutre du Cap, une créature rarement observée. Plus souvent vues sont les antilopes locales: duiker, bushbuck et Cape grysbok; dans la mer, dauphins et baleines sont aperçus en hiver. On a dénombré plus de 200 espèces d'oiseaux dans le Parc National Côtier de Tsitsikamma.* Ci-dessous: *Le pont Paul Sauer traverse la gorge de la rivière Storms. La construction du pont créa une sensation dans les années 1950 quand les deux arches furent abaissées comme un pont-levis et se joignirent à la perfection. Du restaurant, la vue de la gorge est spectaculaire; il y a aussi un pique-nique en bordure de la forêt, et un passage pour piétons sur le pont.*

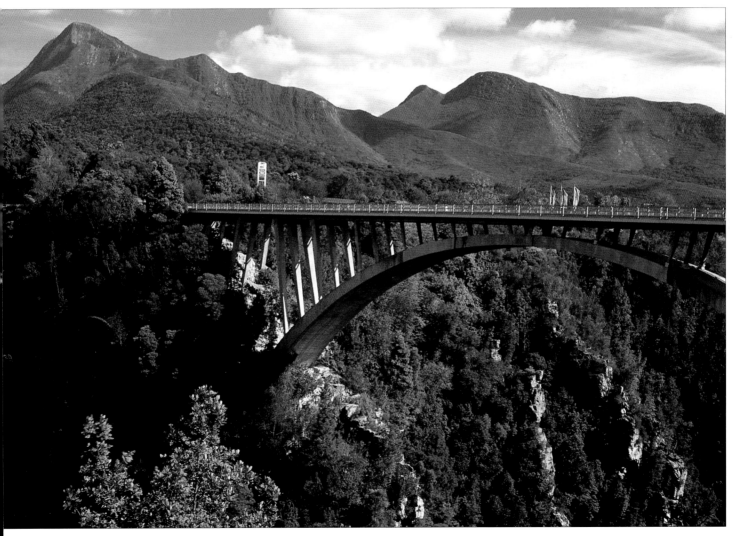

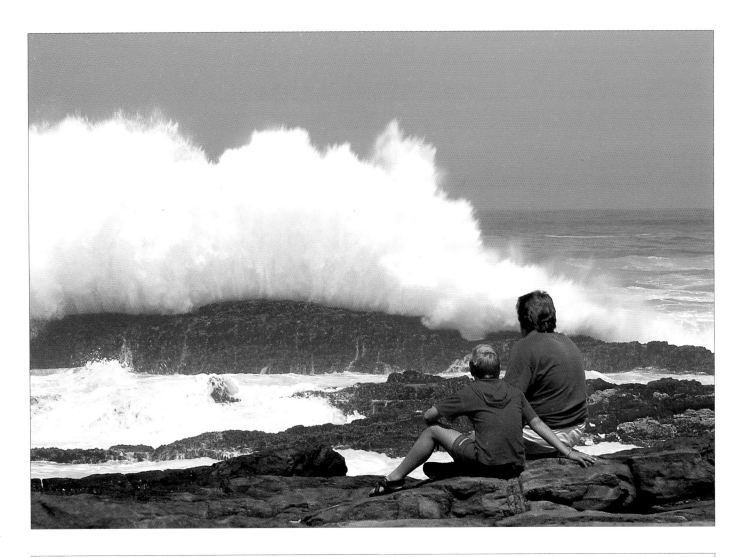

Struik Publishers
(a division of New Holland Publishing (South Africa) (Pty) Ltd)
Cornelis Struik House, 80 McKenzie Street
Cape Town 8001, South Africa

New Holland Publishing is a member of the Johnnic Publishing Group
Website: ***www.struik.co.za***

*Log on to our photographic website **www.imagesofafrica.co.za** for*
an African experience

First published 1995
10 9 8 7 6

Designer: Dean Pollard
German translator: Friedel Herrmann
German editor: Bettina Kaufmann
French translator: Jean-Paul Houssière
French editor: Anouska Good
Cartographer: Nadine Liebenberg

Reproduction by Unifoto (Pty) Ltd, Cape Town
Printed and bound by Kyodo Printing Co (Singapore) Pte Ltd

CLB/Struik Image Library: *pp. 12 (top, centre, bottom left and right),*
16 (bottom); ***Nigel Dennis (Struik Image Library):*** *pp. 19 (bottom right),*
20 (bottom right), 32 (bottom), 33 (bottom right); ***Walter Knirr:*** *p 34 (top);*
Peter Pickford (Struik Image Library): *pp. 14, 38 (bottom right), 43 (bottom).*

Managing editor: Annlerie van Rooyen
Editor: Lesley Hay-Whitton
Design Manager: Petal Palmer

The publishers wish to thank the following organizations
for their kind assistance rendered during the compilation
of this book: National Parks Board, Protea Hotels, Blaricum
Heights Chalets (Knysna), Trail's End Holiday Resort (Swartvlei),
Zellmer Guest House (George), Fairy Knowe Hotel (Wilderness),
Pine Lake Marina (Sedgefield), Penrose Cottage (Great Brak River),
Lake Pleasant Hotel (Sedgefield), Aventura Keurbooms, Eight Bells
Mountain Inn (Robinson Pass), the various pubicity assocciations
along the Garden Route, Frank & Hirsch/Nikon (Cape Town) and
Mid Coast Aviation (George).

ISBN 1 86825 775 4